D1316534

OUTDOOR SCULPTURE IN LANSING

FAY L. HENDRY

photography by Balthazar Korab

ιota press
Okemos, Michigan

NB
235
.L36
H46

Designed by Dorris E. Birchfield, Michigan State University

Typesetting by Superior Graphics, Lansing, Michigan

Printed by Thomson-Shore, Inc., Dexter, Michigan

Library of Congress Cataloging in Publication Data
Hendry, Fay L. 1937-
 Outdoor sculpture in Lansing.
 Bibliography: p.
 Includes index.
 1. Sculpture—Michigan—Lansing. 2. Lansing,
Mich.—Statues. 3. Memorials—Michigan—Lansing.
I. Title.
NB235.L36H46 917.74'270443 80-7502
ISBN 0-936412-02-X

FRONT COVER: Robert Ellison, detail, Untitled
 Photo by Balthazar Korab

BACK COVER: Ulysses Anthony Ricci, detail, Bank of Lansing Reliefs
 Photo by Janet L. Kreger

CONTENTS

v Preface

vii Acknowledgments

ix Foreword Eldon N. Van Liere

1 Outdoor Sculpture in Lansing

11 Outdoor Sculpture by Geographic Areas

13 A. Capitol/Downtown Area

51 B. Riverbank and Northwest

75 C. Southeast

91 D. Michigan State University/East Lansing Area

133 Artists' Biographies

149 Select Bibliography

151 Index

PREFACE

My interest in Michigan sculpture began in 1976 when I was hired by the Michigan History Division, Department of State, to prepare a report on cultural properties for the Coastal Zone Management Program. I intended to include information on sculpture, but when I checked possible sources, I found that practically no information was available. I was told that this wasn't New York or Washington and that there was no information because there was no sculpture.

I wondered if there were sculpture but no information, and began a study of outdoor sculpture in Lansing. Much to my surprise, there was more in the city than I or anyone else had been aware of. While much of what I recorded was not of high aesthetic merit, the sculpture yielded interesting information about the social and cultural history of Lansing. It revealed a city which neither had developed a strong sense of community identity nor had maximized its cultural potential.

The study also revealed the need to create an awareness of and appreciation for sculpture. With awareness and appreciation, there is the potential to enrich our social and cultural heritage and to influence the heritage of future generations. For sculpture not only reflects a community but contributes to it as well. It provokes sensual and intellectual responses, and it records and celebrates the human presence. It is a thread that stitches together the fabric of the past, the present, and the future.

The Lansing study led to slide presentations, tours, a television program, and a photographic exhibition, *Outdoor Sculpture in Greater Lansing: From Tombstones to Titus the Tinner,* which was held at the Michigan Historical Museum from June through December of 1977, the Society for the Study of Midwestern Literature in 1978, and the Honors College at Michigan State University in 1979. The Lansing study also led to the present expanded project, *Outdoor Sculpture in Grand Rapids, Kalamazoo, and Lansing, Michigan,* which began in 1978. Sculpture located and documented in all three cities served as the basis for the preparation of three separate guidebooks and a photographic

exhibition. A public forum on outdoor sculpture will be coordinated with the exhibition which will travel to each city during 1980.

A field inventory was completed for each city of all the sculptural expressions. Free-standing, cemetery, and architectural sculpture was included regardless of aesthetic merit. A cross section of sculpture has been selected from the inventory for the guidebook with an orientation toward social and cultural history rather than aesthetic merit. Both the work of artisan and artist has been included with no intent to obscure the distinction, to disservice art, or to discourage a critical evaluation of the works.

The purpose of the guidebook is to create an awareness of outdoor sculpture in Lansing and to serve as guide and an enticement to actually experience these works. For sculpture is best understood and evaluated when experienced. Entries are brief for this reason.

Entries were also limited in some cases by the constraints of time, money, and accessibility of materials. The research data which have been generated by this project will be housed in the Michigan State University Archives and Historical Collections. It is hoped that this publication will elicit further information about these works and artists. Additional information and corrections are welcomed by the author and may be sent to ιota press, 2749 E. Mt. Hope Road, Okemos, Michigan 48864.

Please note that the date for each sculpture entry refers to the time the work was created and may not necessarily refer to the date commissioned or dedicated. Dimensions refer to height and bracketed information refers to inscriptions. The biographical information for each artist, which includes additional works and their dates when available, has been accepted as given. Sculpture that is mentioned but not illustrated is indicated by a °.

Fay L. Hendry
July 11, 1979

ACKNOWLEDGMENTS

Outdoor Sculpture in Grand Rapids, Kalamazoo, and Lansing, Michigan, could not have been carried out without the help of Professor Eldon N. Van Liere, Michigan State University, and Professor Ronald Watson, Director of the Urban Institute for Contemporary Art and Chairperson of the Art Department, Aquinas College. Cooperation was also given by Fred A. Myers, former Director of the Grand Rapids Art Museum; Harry Greaver, former Director, and Thomas A. Kayser, current Director, Kalamazoo Institute of Arts; and Michael J. Smith, Chief, Michigan Historical Museum (State Museum), Lansing.

Funds for the project were provided by the Michigan State University Development Fund, the Michigan Council for the Arts, the Grand Rapids Foundation, the Kalamazoo Foundation, an anonymous Lansing donor, the Michigan Foundation for the Arts, and the Michigan Council for the Humanities.

Help has also been provided by many individuals and I apologize to anyone whose name has been omitted from the following list: Robert Anderson, Lyle Askew, Roger Ault, Milton Baron, Kenneth C. Black, Henry Blosser, Erling B. Brauner, Alice Brunk, Thomas W. Brunk, Ford S. Ceasar, Howard Church, William Churchill, Sr., Blossom Cohoe, Jack T. Crosby, Sr., Bette Downs, Steve Dugas, Almon J. Durkee, Joyce Dwyer, Drew Eberson, Bob Ellerhorst, Richard Fata, Douglas Finley, Roger Funk, William Gamble, Alan Ginsburg, Bruce Gorsline, George Gurney, Linda Halsey, John A. Hannah, Kent Harder, Clark E. Harris, Richard Hathaway, William Helder, Herbert E. Hendry, Allan Hollingsworth, Bill Hollister, Fred Honhart, Kari Hulsey, Joseph Ishikawa, Helen E. Jacobson, Joe Janeti, Robert Julien, Irene Gayas Jungwirth, Tom Kehler, William H. Kelly, William H. Kessler, Greg Kolodica, George Kooistra, Sylvia B. Kruger, Madison Kuhn, Thelma C. Lamb, Roger D. LaPratt, Ted Levy, Thomas G. Lo Medico, Robert Lott, Jane McClary, Phil McKenna, Catherine Madsen, Elmer Manson, Bob Mattern, Norvall Mercer, Harold N. Metzel, Truman Morrison, O. Jay Munson, Louis Newhouse, Cindy Newman, Robert O'Boyle, Tom

O'Donovan, Georgia Old, Wilson Paul, Lillian Pear, Dorothy Phillips, Vivian Preston, Beth Rademacher, Carol Rapson, Louis G. Redstone, Deobrah S. Reifman, Donald E. Reynolds, George H. Richards, Patricia Rist, Diane T. Robbins, Barbara Allen Robinson, Marilynne Rosenberg, Jon Royer, Ilene Schechter, Robert L. Siefert, Ted Simon, Robert W. Sneden, Marion Soria, Craig Staudenbaur, Marjorie Staudenbaur, Joan Stieber, Shirley Stratton, Shirlee Studt, Richard E. Sullivan, Ruth Syler, Tom O. Thompson, Carroll D. Tietz, Linda Wagner, Alfred Wardowski, Wendell Wescott, Geneva Kebler Wiskemann, Martin Wynalda, and Ed Zabrusky. I am, of course, indebted to all the artists both living and dead who are the substance of this project.

FOREWORD

The public sculpture, researched and catalogued almost single-handedly by Fay Hendry and masterfully photographed by Balthazar Korab, presented in this guide documents the works in this community which have survived from the past and those which are being created today. The old sculptures are familiar for they have been around a long time, but they have become remote in meaning, and much of the most modern of sculpture seems remote by design. Public sculpture has never had an easy time of it, for it is asked to do the impossible—to please a wide diversity of tastes and interests. The very fact that it is public and thereby unavoidable tends to make it controversial.

In the past public sculpture, whether it served to decorate a building or was a freestanding work, served very clear humanizing purposes. More often than not the intent was didactic, and when it was not, as in the case of an ornamental carving, its purpose was to give the eye a moment of delight. Modern taste has done much to obscure these monuments from the past with the exception of those sacred precincts where we have buried the past and collected monuments to the dead. Beyond these hallowed grounds the market place takes over, and the monuments that dominate are huge impersonal buildings of a democratic sameness lacking, or nearly so, that humanizing touch of decorative sculpture. The older buildings which survive and do have some sculpture adorning them seem either quaint or too unique to exist comfortably with the shivering towers of steel and glass that surround them. It is as if these reminders of past individualism are threats to a predominant concept of equality and sameness.

If modern architecture has left little room for the decorative or allegorical relief on its surfaces, it has completely dwarfed the freestanding sculpture both old and new. To be sure, man has been made puny by much of modern architecture, but we for the most part accommodate ourselves to it; however, should that urban pedestrian look up and take note of some sculpture dwarfed by monuments to commerce and politics, he or she might be struck by how scale and

space have changed in the twentieth century. The old sculpture may have been preserved, but very often its setting has not, and the sculpture comes out the loser. Much of modern sculpture has adopted an industrial tone with its use of polished chrome-like surfaces or sheet steel, rusted or painted, welded or bolted together allowing for a scale that can attempt to compete with huge buildings in a vernacular common with them and be eye-catching in the midst of an urban bustle.

Modern sculpture with its concerns for pure form has the potential of universality. Pure form can be understood by all and/or be moving to all; but, despite this potential, it is, nevertheless, found incomprehensible by many. Pure form does not read like a bronze figure of a dancing young woman draped in garlands of flowers representing Spring. To the viewer with an eye for pure form the very pose of such a figure with its tensions and balances may be most satisfying, but the allegorical aspect is a distraction. On the other hand, the message of Spring's celebration of a liberation from winter and the hope for the fertile months ahead as well as a comprehensible technical skill at rendering a likeness are understandable to all. Thus, there is in the dancing maiden a community comprehension on a multitude of levels denied by many modern works despite their "universality." Sculpture free of representation and allegory in search of purity can be and has come to be appreciated or accepted by many, but it does not serve to reinforce any vision of public values other than the belief that art has a place in public life and in some general way is uplifting and enriching.

This guidebook is an attempt to help us all pause as we hurry by and take note of how one generation sought to speak to another without asking us to go into a museum or pore over a book. The illustrations herein isolate the sculpture as much as possible from the competing and often overwhelming surrounding distractions to help direct our eyes to what we have here and perhaps inspire us to make public sculpture a meaningful expression of our own time.

Eldon N. Van Liere

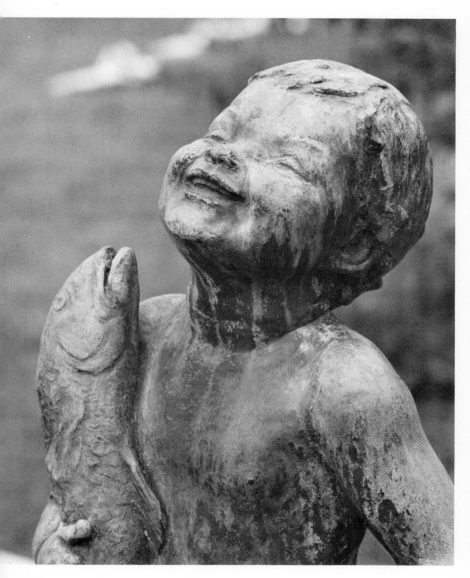
Detail: Edith Barretto Stevens Parsons, *Fish Baby* (C-7, p. 88).

OUTDOOR SCULPTURE IN LANSING

By the 1830s Michigan was ripe for statehood. The fur trade was peaking, the Indians had ceded most of their lands, and transportation was greatly facilitated by the construction of arteries like the Erie Canal and the Old Sauk Trail (US 12). Land speculators and settlers, primarily from New England and New York, began to stream into the territory.

When Michigan achieved statehood in 1837, Detroit was designated the temporary capital for the next decade. The permanent site of the capital was a hotly debated issue, and to settle the dispute, a site was selected in the center of the state at the urging of James Seymour. Seymour was a land speculator from New York who served to profit from the sale of land in the area. At that time there were only a few scattered settlers in a swampy forest along the Grand River and it was necessary to plat the town of *Michigan*. A year later, on April 3, 1848, the name of the town was changed to Lansing at the request of some of the early settlers who had come from Lansing, New York. Their hometown had been named after Chancellor John Lansing of that same state. In spite of the official name for the city, rival factions tended to ignore it and identify instead with Upper Town in north Lansing, Middle Town around the Capitol area, or Lower Town in south Lansing until at least the end of the nineteenth century. A few miles to the east of Lansing, another enclave developed in 1855 with the establishment of the first agricultural school in the United States, Michigan Agricultural College.

It is not known for certain when the first sculptor or stone carver came to Lansing, though a stone carver likely followed the settlers to carve the inevitable grave marker. Samuel Durant, author of the *History of Ingham and Eaton Counties* (1880), noted that "John W. Butler was the first to engage in the marble business in Lansing. He opened a shop about 1852,...(p. 136)." These early marble slabs repeat many of the motifs which were used in the East. Winged angels, roses, and weeping willows, all commenting on the life and death cycle, offered solace to those who mourned and new life in heaven for those who had died.

Besides grave markers, stone carvers sometimes carved their civic monuments in direct competition with sculptors. They sometimes also collaborated with a sculptor by carving the pedestal for a work or by translating the sculptor's model into stone. This was the case with Carl Herman Wehner who modeled the clay figures for the Capitol pediment relief, *The Rise and Progress of Michigan* (1876) [p. 17]. Working in a room of the Capitol Building while it was under construction, Wehner reproduced his clay models in plaster of paris and then turned them over to the stone carvers to execute in sandstone. Wehner, who maintained a studio in Lansing for a brief while after the commission, may have been one of Lansing's earliest sculptors.

The Capitol Building, proud symbol of statehood, carries Wehner's allegorical relief on its pediment. A nineteenth century version of progress, Michigan is portrayed as a "refined" white woman who has cast aside the "barbaric" Indian civilization. She is flanked by Commerce, Agriculture, Lumbering, and Mining. Other sculptures which depict Lansing's pioneer beginnings and later industrial developments are Ulysses Anthony Ricci's reliefs on the Bank of Lansing (1931-1932) [p. 30] and Leonard Jungwirth's city seal relief on the City Hall (c. 1956-1958) [p. 25]. The founding of Michigan Agricultural College is commemorated by Lee Lawrie's relief of *The Sower* on Beaumont Tower (c. 1929) [p. 113].

The denigrating view of the American Indian on the Capitol pediment is typical of public sentiment toward the Indian who had come to be regarded as a nuisance in the nineteenth century. In the eighteenth century the Indian had been viewed as a noble savage and it was not until the twentieth century that this notion was revived. The romanticized view that prevailed earlier in the twentieth century is reflected in the *Chief Okemos Memorial* (1923) [p. 131], while a more sobering attitute is reflected in the recent works by Peter Toth, *Indian Monument* (1976) [p. 76], and Melissa Williams, *Ascension* (1976) [p. 119].

By the end of the Civil War, communities in the Midwest had begun to improve and beautify their cities. Modest buildings were replaced with more substantial and elegant ones like the Capitol Building, and practical items such as cast iron clocks and fountains began to appear.

Though the fountain at Reutter Park (Central Park) no longer exists, the Seth Thomas Clock° still stands in front of Morgan's Jewelers where it was placed more than one hundred years ago.

Another civic improvement was the development of cemeteries which also served as public parks. This type of rural cemetery had been developed in the East around the time that settlers began to move into Michigan. Mt. Hope Cemetery was laid out in 1873 with all the requisite features of a picturesque cemetery-park. Curving roads wound through hills and valleys covered with trees and grass. The beautiful settings, considered works of art in themselves, stimulated the creation of larger and more elaborate monuments to impress, inspire, and charm the visitors. Two interesting Victorian monuments carved by stone carvers and located in Mt. Hope Cemetery are "Owl in a Tree Trunk" (after 1875) [p. 82] and "Woman Clinging to a Cross" (date unknown) [p. 87].

Communities also found the time and money to memorialize their heroes. Statues of soldiers, politicians, poets, and civic leaders were erected to serve a dual purpose. They honored the past and they were morally uplifting to present and future generations. When Edward Clark Potter's statue of Governor Blair (1897) [p. 15] was unveiled on the Capitol lawn in 1898, the Honorable John Patton delivered a moving address on Blair's virtues as a leader during the Civil War. Patton reminded the huge crowd that the memorial was erected so that Blair "may stand here as a teacher of that heroic time, and that the noble influence which he exerted may be recalled and perpetuated among our children's children (*Lansing State Republican* 12 October 1898:2)." Like the Blair statue, many memorials were not erected until long after the death of the person or event they commemorated. Unnoticed today, they remain a testimonial to the fervent patriotism of their times. They also reflect the belief that wars were waged for humanitarian reasons.

Hardly a city is without its war memorial and Lansing lays claim to several in addition to the Blair monument. One of the earliest war

°Here and hereafter indicates that the sculpture under discussion is not illustrated.

memorials is an obelisk carved by local monument makers J. L. Stewart and E. L. Hopkins °. This monumental form was borrowed from the Egyptians for both public and private memorials. The most well-known public memorial in the United States is the Washington Monument (1848-1886) located in Washington, D.C. As a private memorial, obelisks can be found in countless cemeteries throughout the United States. The Stewart and Hopkins Civil War monument was erected in Mt. Hope Cemetery between 1875 and 1880 under the auspices of the Ladies' Monument Association of Lansing.

In addition to the Blair memorial, two other Civil War monuments and a Spanish American War Memorial are located on the Capitol lawn. They include Frank D. Black's *First Michigan Sharpshooters* (1915) [p. 21]; the *First Regiment Michigan Engineers Monument* (1912) °; and Theodore Alice Ruggles Kitson's *The Hiker* (c. 1945) [p. 18]. *Austin Blair* and *The Hiker* were modeled by well-known American artists, while the other two were carved by monument makers. The selection of such a prominent public site is further evidence of the civic virtue of monuments. The memorials also reflect the strong antislavery sentiment in Michigan during the Civil War and the later popularity of the Spanish American War.

The decline of the war memorial, and memorials in general, began in the United States after the disillusionment of World War I, despite our victory. Contributing to this decline was a preference for memorials in the form of parks or buildings rather than sculpture. After World War II, *Little Arlington* (1950) ° was erected in Evergreen Cemetery. It was carved by monument maker Charles A. Pizzano of Barre, Vermont. Since the Vietnamese Conflict, antiwar sentiment has led to the destruction of past monuments and to the creation of protest and peace monuments. Reflecting something of this new attitude is H. James Hay's recent *Tree of America* (1976) [p. 71] which provides a peaceful guise for a war memorial.

The period between the Civil War and World War I was indeed the golden age of the commemorative monument. Sculptor and citizen alike felt the need to express American ideals in equally lofty styles. The classical Beaux-Arts style, so-called because its source was the École des

Beaux-Arts (National Academy of Fine Arts) in Paris, became an "official" style for American ideals. The Beaux-Arts style reached its sumptuous apogee at the Chicago Worlds Columbian Exposition of 1893 and lingered on into the 1930s. Kristian Schneider's terra cotta reliefs on the facade of the Michigan Theatre (1921) [p. 26] reflect the decorative aspects of the style. High cost and the preference for streamlined modern architecture sounded the death knell for decorative terra cotta during the depression.

The seminal modern art movement had already begun to challenge the flourishing Beaux-Arts school at the beginning of the twentieth century. Artists began to carve directly in wood and stone. Since they responded to the natural forms of the material, their works tended toward abstraction. The stone carver was thus eliminated and works became smaller and more intimate. A new class of patrons was beginning to develop which could afford sculpture for private settings, though their tastes continued to embrace traditional styles rather than modern art. Garden sculpture like Edith Barretto Stevens Parsons' *Fish Baby* (c. 1915-1920) [p. 88] was popular, and there was an increase in funerary memorials like Leonard Crunelle's *Dr. George E. Ranney Relief* (c. 1914) [p. 84].

Between World War I and World War II, a new style developed which was more in keeping with the twentieth century. Once again, the style originated in Paris and was called Art Moderne or Art Deco after the 1925 Exhibition of Decorative and Industrial Arts. This crisp, geometric style created a streamlined yet bold effect which is reflected in Lee Lawrie's *The Sower*. Art Deco, particularly as a figurative style, continued on through the 1950s in a progressively bland manner. The allegorical figure on Leonard Jungwirth's *City Seal* (c. 1956-1958) [p. 25] is a late example of the super-muscled heroes who represented American ideals until an abstract vocabulary received public support and acceptance in the 1960s.

The 1930s depression provided an impetus for the proliferation of these bulky, angular figures. During this period of social concern, there was an inward turning and an emphasis on the individual worker. The United States government emerged as a patron of the arts through

programs like the Works Progress Administration (WPA), Federal Art Project. Initiated in 1935, the name of the program was changed to the Work Projects Administration in 1939 and was terminated in 1942. Both Lansing and Michigan State University actively participated in WPA projects which produced works like Samuel Cashwan's *Aquarius* (1938-1939) [p. 48] and Clivia Calder Morrison's *Children Reading* (c. 1938) [p. 107]. Though not a WPA project, Corrado Joseph Parducci's figural reliefs on the Michigan Bell Telephone Building (1941) [p. 39] portray the worker as the backbone of our nation during the depression and ensuing war years.

It was not until after World War II that modern sculpture began to blossom, even though the seeds had been sown and cultivated throughout the first half of the nineteenth century. Traditional form (often the human form) and space were in the process of transformation through new materials, techniques, and thought. Representational forms were abstracted into organic and geometric forms. The relationship of space to a solid mass was altered by incorporated space within the form. As pedestals began to disappear, space was increasingly extended and the viewer was increasingly involved with the work. Such spatial transformations have paved the way for today's large-scale works which embrace a total environment.

The application of industrial materials like steel and plastic and industrial techniques like welding allowed sculpture to be constructed rather than modeled or carved. Sculpture could incorporate found objects or have movable parts. Sculptors were no longer bound to express heroic American ideals in their work but were free to explore sculpture as an individual expression. Today, the subject of sculpture may be form, materials, process, or something as ephemeral as a concept or performance. The dimensions of sculpture can be stretched even further if one includes permanent works like photographs or video tapes which document ephemeral art.

Lansing's first abstract work was Donald March's *World Without End* (1961) [p. 36] which evoked a puzzled response from those who happened to notice it. During the 1960s urban renewal programs were initiated across the United States in an attempt to revitalize decaying

inner cities. Old structures were razed to make way for the North Washington Square Mall and Riverfront Park in downtown Lansing. Plans for the mall included a gateway sculpture and Robert Youngman's textured wall reliefs and fountain (1972-1973) [p. 35]. Through the efforts of the Lansing Fine Arts Council, Lansing received a grant from the National Endowment for the Arts, and Claes Oldenburg was selected to create the mall sculpture. Oldenburg's controversial sculpture proposals were not accepted, and José de Rivera's *Construction #150* (1972) [p. 29] was ultimately selected for the site "as a timeless reminder of the city's vitality, progessive spirit, and cultural growth." De Rivera used industrial materials and techniques to create a curvilinear form which encloses space while moving through it at the same time. This little jewel has not had the intended impact; it not only lacks an appropriate site, but also lacks appreciation.

Ironically, Martin Eichinger's *Windlord* (1978) [p. 53] grew out of the negative response to *Construction #150*. The *Windlord*, located in Riverfront Park, was directly commissioned by the city from a Lansing sculptor for slightly more than half the cost of *Construction #150*. The *Windlord*, with its readily recognizable image, will undoubtedly be more popular than de Rivera's work. Also located in Riverfront Park is Robert Weil's *Salt Shed* (1975-1976) [p. 55]. Once again the government has become a patron of the arts through programs like urban renewal, the National Endowment for the Arts, the General Services Art-in-Architecture Program, and the Michigan Council for the Arts.

The Bicentennial celebration of 1976 also acted as a spur to recent sculpture. Though not completed until two years later, Eichinger's *Windlord* was originally proposed as a Bicentennial project. Also associated with the Bicentennial celebration are H. James Hay's *Tree of America;* Melissa Williams' *Ascension;* and Thomas Young's untitled work (1976) [p. 117]. The latter was created for East Lansing's outdoor sculpture exhibition *From the Bottom Up: Fifteen Contemporary Michigan Sculptors,* which coincided with the Bicentennial celebration. The exhibition received a mixed response and generated a healthy dialogue. Young's piece and Jack Bergeron's *Longform* (1976) [p. 79] were retained by the community after the exhibition.

Since the 1960s there has been an increase in sculptural activity in the community promoted by government, business, churches, and other private groups. And yet, given a city government, a state government, General Motors Corporation, and Michigan State University, Lansing has not lived up to its potential. There is no sculpture which has made an impact on the community or one with which the whole community identifies. Lansing's sculpture tends rather to serve as focal points for segments of the community. Leonard Jungwirth's *Spartan,* popularly known as "Sparty," (1944) [p. 103] is a focal point for Michigan State University as is Samuel Cashwan's *Open Cage* (1966) [p. 44] for Oldsmobile Division, General Motors Corporation. Other works which commemorate the fact that Ransom Eli Olds put Lansing on the map as an automobile center are Ricci's reliefs on the Bank of Lansing which portray a Reo Flying Cloud; a granite stelae by monument carver Frank Yogerst (1953)° which marks the site of Olds early experiments; and Woody Sanford's untitled work (1974) [p. 46] composed of Delta 88 automobile parts.

Lansing has been too long "without the pale of civilization." This phrase was used by former Governor William L. Greenly at the Capitol dedication to characterize the selection of the permanent site for the capital city, a site which was treated as a joke and not taken seriously until the construction of the Capitol Building in the 1870s. It's as if the die were cast back in 1847 when the site was wrenched from Detroit and a boom town was thrust upon a few settlers in a wilderness far away from the more established centers in the southern part of the state. Segmented from the beginning, Lansing has been affected by land speculators, legislators, educators, students, and corporate employees who have no long term interests in the city. Potential leadership, like potential sculpture, has not materialized in the past.

Bold moves like de Rivera's *Construction #150* have been made but have suffered similar fates. In 1895 the State of Michigan commissioned *Austin Blair* from a noted American sculptor, Edward Clark Potter. Two other sculptors of national reputation created works for Michigan State University. They are Lawrie's *The Sower* and Carl Schmitz's reliefs for the Physics and Astronomy Building (1947) [p. 101].

Lansing appears to be providing a new impetus which is reflected in recent sculpture commissions. Each is a large environmental work which has the potential to provide a collective identity for the city. Melvin Leiserowitz's untitled work (1979) was recently dedicated at the site of the State Center for the Performing Arts at Michigan State University [p. 93] and Michael Heizer's *This Equals That* [p. 23] and Joseph Kinnebrew's *William A. Brenke River Sculpture/Fish Ladder* [p. 57] are scheduled to be completed in 1980.

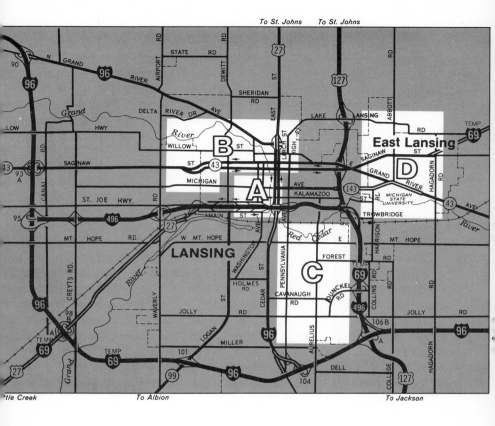

OUTDOOR SCULPTURE
BY GEOGRAPHIC AREAS

A. CAPITOL/DOWNTOWN

B. RIVERBANK AND NORTHWEST

C. SOUTHEAST

D. MICHIGAN STATE UNIVERSITY/
 EAST LANSING

11

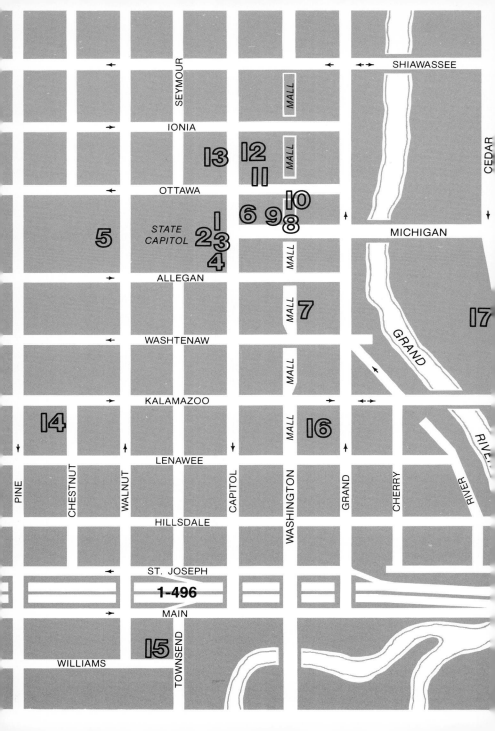

 CAPITOL/DOWNTOWN AREA

1. Edward Clark Potter, AUSTIN BLAIR
 Capitol Lawn

2. Carl Herman Wehner, RISE AND PROGRESS OF MICHIGAN
 Capitol Building

3. Theodore Alice Ruggles Kitson, THE HIKER
 Capitol Lawn

4. Frank D. Black, FIRST MICHIGAN SHARPSHOOTERS
 Capitol Lawn

5. Michael Heizer, THIS EQUALS THAT
 State Capitol Complex

6. Leonard D. Jungwirth, CITY SEAL
 Lansing City Hall

7. Kristian E. Schneider, MICHIGAN THEATRE RELIEFS

8. José de Rivera, CONSTRUCTION #150
 North Washington Square Mall

9. Ulysses Anthony Ricci, BANK OF LANSING RELIEFS

10. W. Robert Youngman, FOUNTAIN AND WALL RELIEFS
 North Washington Square Mall

11. Donald H. March, WORLD WITHOUT END
 Davenport Building

12. Corrado Joseph Parducci, MICHIGAN BELL TELEPHONE RELIEFS

13. Corrado Joseph Parducci, SUFFER THE LITTLE CHILDREN
 First Baptist Church

14. Artist Unknown, "BOY READING A BOOK"
 Education Building

15. Samuel A. Cashwan, OPEN CAGE
 Oldsmobile Administration Building

16. Woody (Edwin W.) Sanford, UNTITLED
 Story, Inc.

17. Samuel A. Cashwan, AQUARIUS
 Water Conditioning Plant

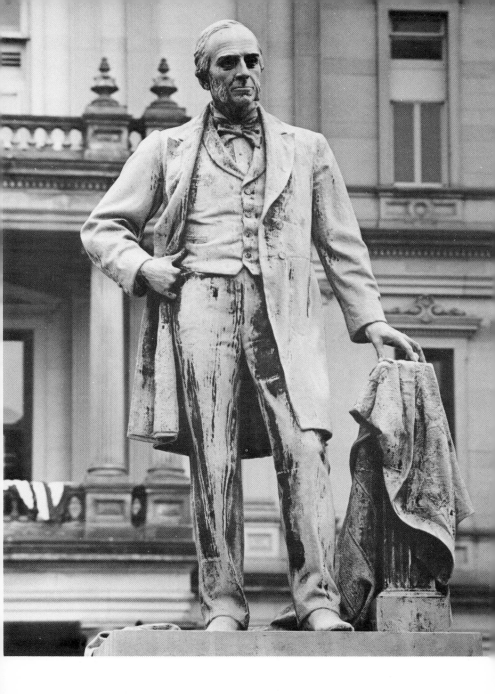

Edward Clark Potter (1857-1923)

AUSTIN BLAIR

1897, bronze, 9'
[E. C. Potter, 1897 Bureau Brothers Bronze Founders]

Capitol Lawn
Michigan and Capitol avenues, Lansing

Early in 1895 two resolutions were introduced in the Senate to commission a statue of "Michigan's War Governor" Austin Blair (1818-1894). The first resolution would have placed the statue in the National Statuary Hall in Washington, D.C., but the second resolution, placing the state on the Capitol lawn, won the day. Modeled by the noted American sculptor Edward Clark Potter, the statue was dedicated amidst dignitaries, parades, speeches, and much ceremony on October 12, 1898. Blair, a lawyer and politician, served as Governor during the Civil War. He spoke out eloquently against slavery and excerpts from his speeches can be found on the granite base. Dressed in a frock coat, Blair strikes an oratorial pose while resting his left hand on a flag-draped column. Both the pose and the column allude to the orators and ideals of ancient Greece.

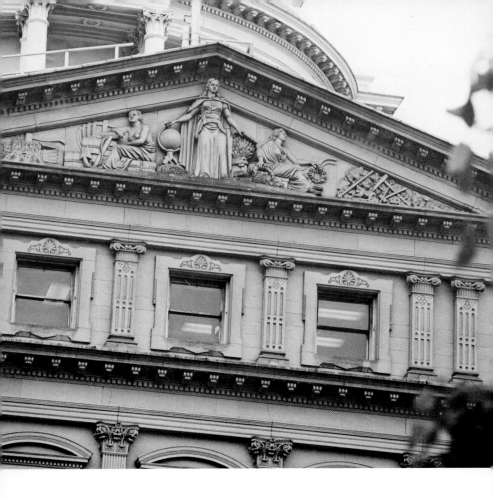

Carl Herman Wehner (1848-1921)
RISE AND PROGRESS OF MICHIGAN
1876, sandstone, MICHIGAN 8'

Capitol Building
Capitol and Michigan avenues, Lansing

The statuary group on the pediment of this classical building, designed by Elijah E. Myers (1832-1909), allegorically relates the rise and progress of Michigan. The pediment design was apparently jointly conceived by Detroit portrait painter Lewis T. Ives (1833-1894) and Herman Wehner. Wehner was given a room in the Capitol Building while it was under construction to prepare models of the figures for the stonecutter. The central figure of *Michigan*, "a refined white woman in Indian costume," has cast aside the "emblems of barbarism, a scalping knife and tomahawk," in favor of civilization, represented by the book and globe. She is surrounded by the major industries of the nineteenth century, lumbering, commerce, agriculture, and mining.

 A-3

Theodore Alice Ruggles Kitson (1871-1932)
THE HIKER
c. 1945, bronze, 8'5"
[Theo. A. R. Kitson Sc Gorham Co. Founders]

Capitol Lawn
Capitol and Michigan avenues, Lansing

The hiker, so called because of his long hikes in the hot
steaming jungles, fought in the name of freedom, humanity,
and patriotism in Cuba and the Philippine Islands and in a
relief expedition to China during the Boxer Rebellion. The
romanticized treatment of this foot soldier suggests the
popularity of "this splendid little war," the Spanish-American
War of 1898-1902, in which the United States emerged as a
world power and expanded its territories to include Puerto
Rico, Guam, and the Philippine Islands. The freed colonies
are represented in the cruciform plaque on the pedestal by a
woman who kneels before a soldier and a sailor while the
U.S.S. *Maine* floats in the background. The United Spanish
War Veterans of Michigan collected funds from veterans
throughout the United States for this monument and
presented it to the State of Michigan during dedication
ceremonies on September 15, 1946. Approximately fifty
other castings can be found in cities throughout the United
States, including the original which was erected at the
University of Minnesota in 1906. Two others can be found
in the Michigan cities of Kalamazoo (c. 1923) and Grand
Rapids (c. 1927).

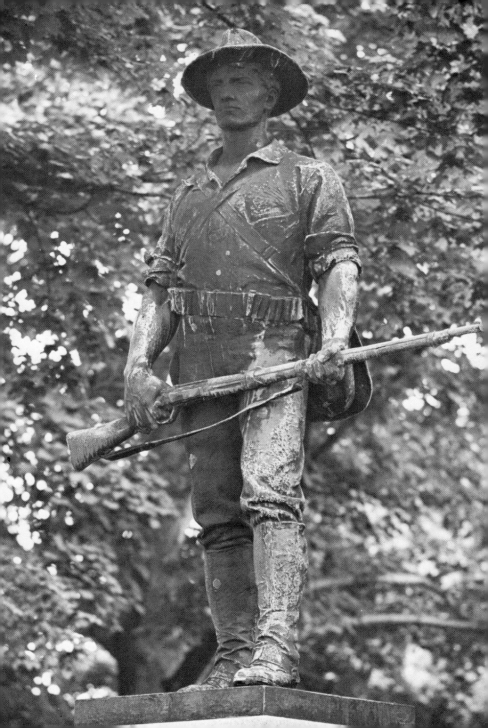

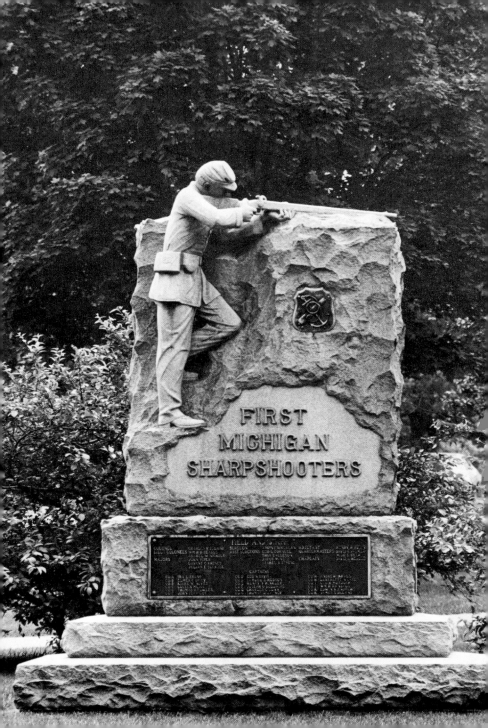

FIRST
MICHIGAN
SHARPSHOOTERS

HELD AND STAFF

Frank D. Black (1863-1927)

FIRST MICHIGAN SHARPSHOOTERS

1915, granite, 12'

Capitol Lawn
Allegan Street and Capitol Avenue, Lansing

On April 1, 1915, the State of Michigan passed a concurrent resolution allowing the survivors of the First Regiment of the Michigan Sharpshooters to erect a memorial on the Capitol lawn at their own expense. This regiment, which fought in the Civil War under General Ulysses S. Grant, was engaged in the seige and capture of Petersburg, Virginia. On April 3, 1865, they were first to enter the city and first to fly their flag over the courthouse. The monument was designed and built by Frank D. Black, a Grand Rapids monument dealer, and placed on the Capitol lawn in October of 1915.

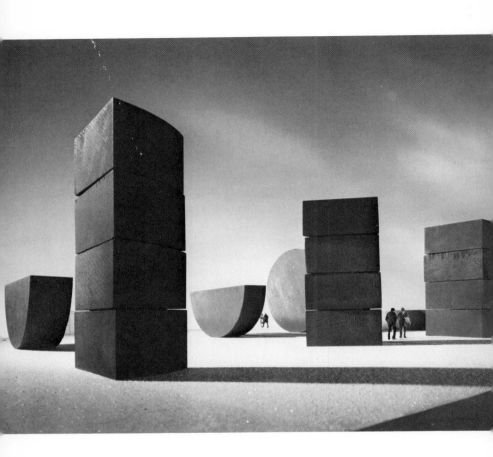

Michael Heizer (1944-)

THIS EQUALS THAT

current model 1979, concrete, horizontal disc 48′

State Capitol Complex
Walnut between Allegan and Ottawa streets, Lansing

Commissioned as a pilot project by the Special
Commission on Art in State Buildings, this large
environmental work is scheduled to be completed in
1980. Funds will be provided by the government and
private sources. The work, which contrasts with the
surrounding rectilinear buildings, consists of a 48-
foot circle which has been segmented into four 24-
foot circles, three of which have been further
divided into halves, quarters, and eighths. As people
move through the geometric parts of the whole,
they will be able to mathematically experience that
This (the large circle) *Equals That* (the sum of its
parts).

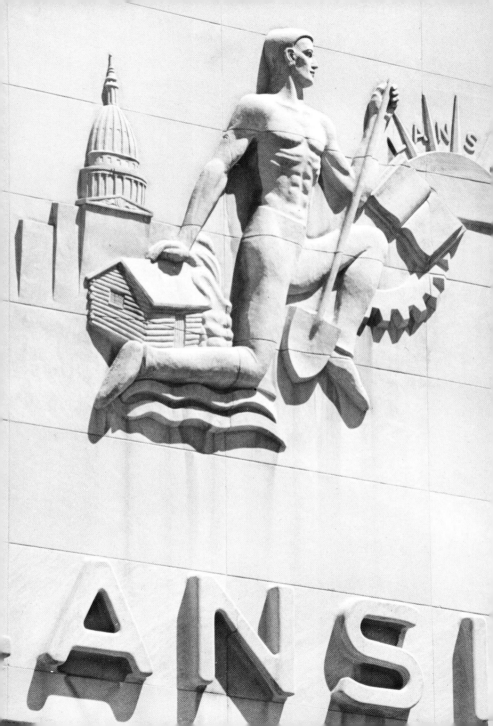

Leonard D. Jungwirth (1903-1963)
CITY SEAL

c. 1956-1958, limestone, 9′

Lansing City Hall
Michigan and Capitol avenues, Lansing

This adaptation of the city seal of Lansing was modeled
by Michigan State University professor Leonard
Jungwirth for the new City Hall. The building was
designed by Lansing architects Lee (1877-1960) and
Kenneth C. (1901-) Black and dedicated on
February 17, 1959. This masculine personification of
the city rests his knee on the Grand River and holds a
shovel, representing agriculture, in his left hand. His
right hand rests on a log cabin, pointing to Lansing's
beginnings as a "city in the forest." The Capitol
Building marks Lansing as the state capital while the
gear refers to industry, the book to education, and the
sun to the bright future of Lansing.

Kristian E. Schneider (1863-1935)
MICHIGAN THEATRE RELIEFS
1921, terra cotta, roundel 4', caryatid 5'

Michigan Theatre (Strand Theatre and Arcade)
215 S. Washington Square Mall, Lansing

This lavish theater and arcade was designed by the well-known theater architect John Eberson (1875-1954) for theater entrepreneur Colonel Walter Scott Butterfield (1868-1936). Though the theater has seen many changes since its vaudeville days, including the Art Deco alterations of the 1940s, these lovely ladies continue to grace the building facade. They were modeled in Chicago by Kristian E. Schneider who was architectural modeler for Chicago architect Louis Sullivan (1856-1924). Though it is not documented, it would appear that the young girl in the roundel is a composite portrait of Colonel Butterfield's daughters.

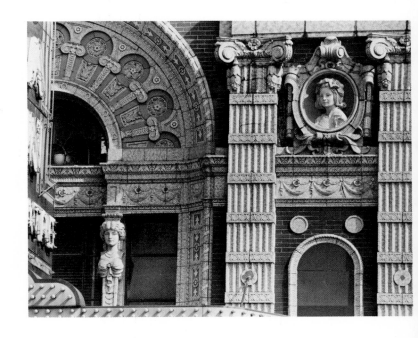

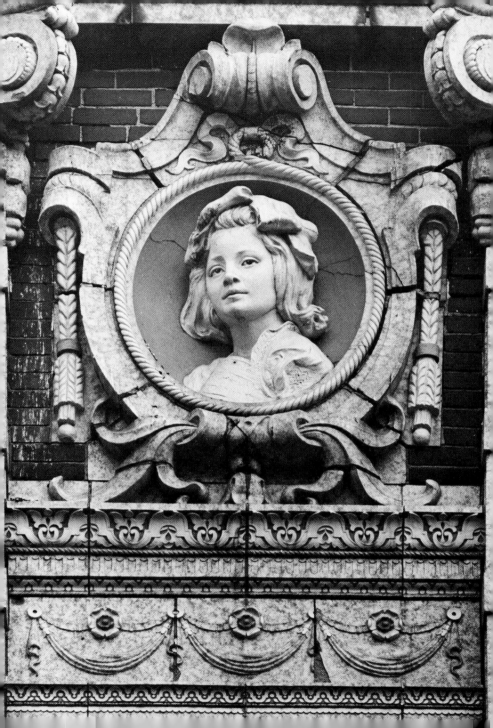

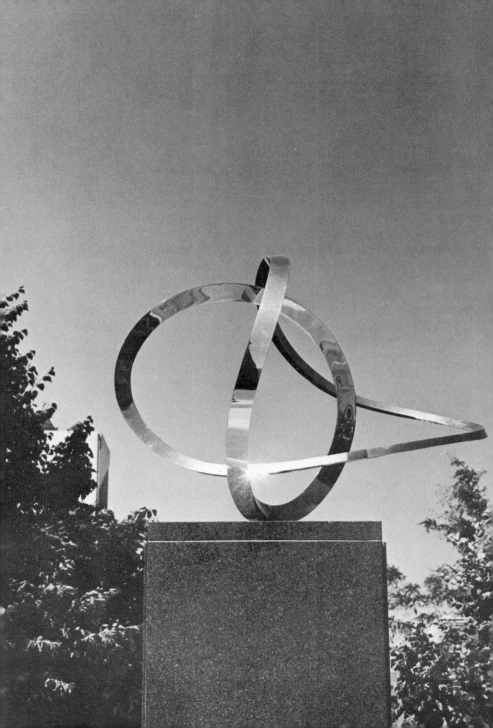

José de Rivera (1904-)
CONSTRUCTION #150

1972, stainless steel, 3'9"

100 N. Washington Square Mall, Lansing

In 1970 the Lansing Urban Redevelopment Board asked the
Metropolitan Lansing Fine Arts Council to provide leadership for
securing a sculpture for the new downtown mall. Two years later
a sculpture committee received a $45,000 grant from the National
Endowment for the Arts which was matched by an equal amount
of private monies. They selected Claes Oldenburg (1929-),
who proposed a catcher's mitt, an alphabet Good Humor Bar, an
ashtray, and a saw. The first two were accepted in that order, but
were never commissioned due to fabrication problems. The
committee then purchased *Construction #150* from José de Rivera.
This motorized work is composed of elegant curvilinear forms and
encompassing voids which are continuously changed by motion
through time and space and by the reflection of light from the
highly polished surfaces. The sculpture, dedicated on November
30, 1973, remains a controversial work due to its small size, cost,
poor site, and abstract form and content.

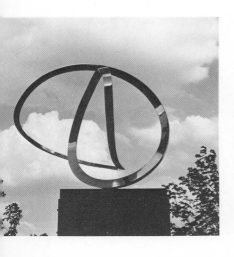
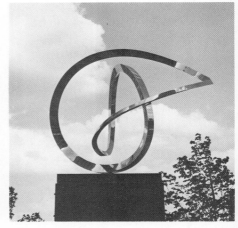

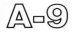

Ulysses Anthony Ricci (1888-1960)

BANK OF LANSING RELIEFS

1931-1932, limestone, marble, and bronze, arch 30'6"

Bank of Lansing (City National Bank)
101-103 N. Washington Square Mall, Lansing

Designed by Lee (1877-1960) and Kenneth C. (1901-) Black, this building is unique for its elaborate interior and exterior articulation. So unique, that one of the interior corbel figures portrays Kenneth Black, who was then young and beardless, with a beard. When asked why, Ricci responded that the architect would grow one much longer before Lansing built a similar building. Drawing on medieval wit and a Romanesque vocabulary, the sculptural program tells the history of Lansing and the role of the bank in the community.

The elephants atop the marble columns served as a logo for the City National Bank and represent the strength of the bank. Beginning at the top of the left pilaster, a figure holds the Reo Flying Cloud, a car which was manufactured in Lansing. The center figure holds a wheelbarrow representing the Lansing Company's product which was sold nationwide. The bottom figure holds a plow, symbolic of the farming community (see p. 32). The right pilaster's upper figure holds a book and a lamp, symbolic of the educational institutions, including Michigan Agricultural College (now Michigan State University). The center figure holding a cross represents the religious community. The lower figure holds the Capitol dome which marks Lansing as the capital of the state. The capitals of the pilasters contain images taken from United States coins. The central figure on the inner curve of the arch symbolizes law and is flanked by a merchant with a cash register and a man with a thermometer representing medicine. The corbel figures in the windows portray a dentist and his patient and a bank robber and a policeman. The bronze door panels (see p. 33) from upper left to lower right refer to safety deposits, wise investments, the previous bank building, industry, agriculture, prosperity, *memento mori* (a reminder of man's mortality), and commerce.

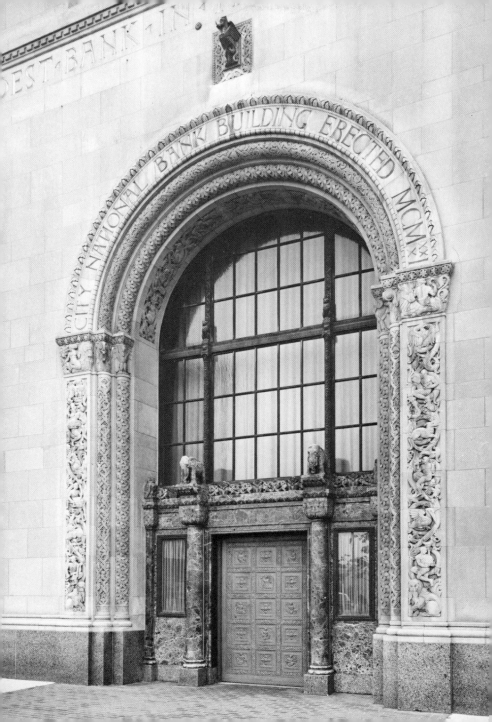

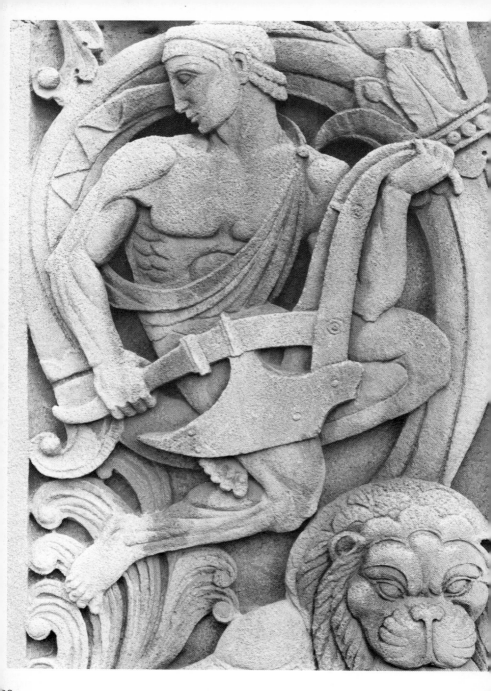

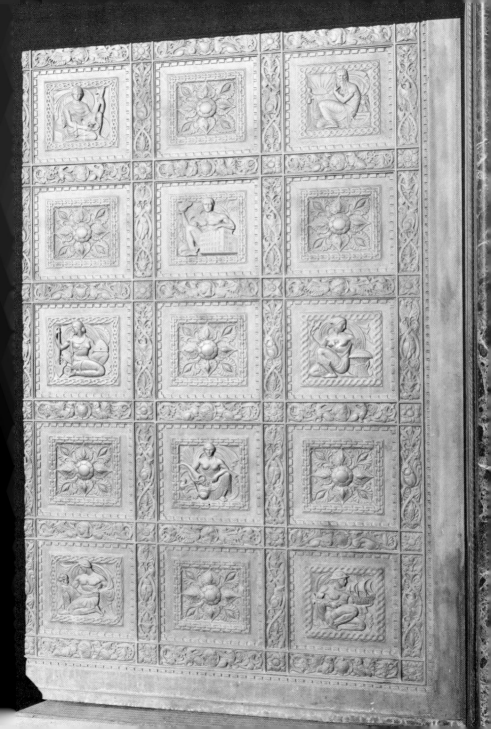

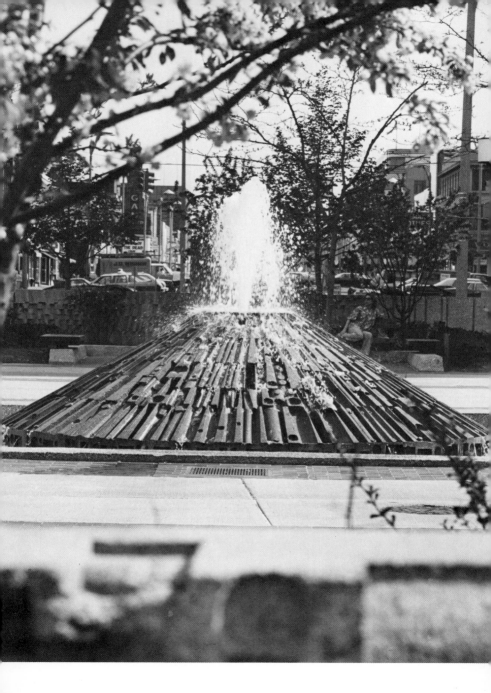

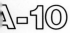

W. Robert Youngman (1927-)
FOUNTAIN AND WALL RELIEFS

1972-1973, concrete, FOUNTAIN c. 4'

North Washington Square Mall
between Michigan Avenue and Shiawassee Street, Lansing

This mall, an urban renewal project, was designed by
Johnson, Johnson and Roy. The truncated cone-
shaped fountain, which contains stained glass panels,
is composed of cast concrete forms and voids which
are also incorporated in the U-shaped wall units
found throughout the mall. The varied patterns of
these reliefs, which have been sandblasted to
enhance their textural quality, shift and change with
the play of light.

A-11

Donald H. March (1926-)
WORLD WITHOUT END
1961, brass, 7'
[Don March, Grand Rapids, 1961]

Davenport Building
Ottawa Street and N. Capitol Avenue, Lansing

Commissioned for the exterior of the building by developer James R. Bronkema, this sculpture was probably the first abstract public work to appear in Lansing. The variations in the size of the brass rectangular forms and their spatial relationships, along with the endless variations of light, suggest that this small world is without end.

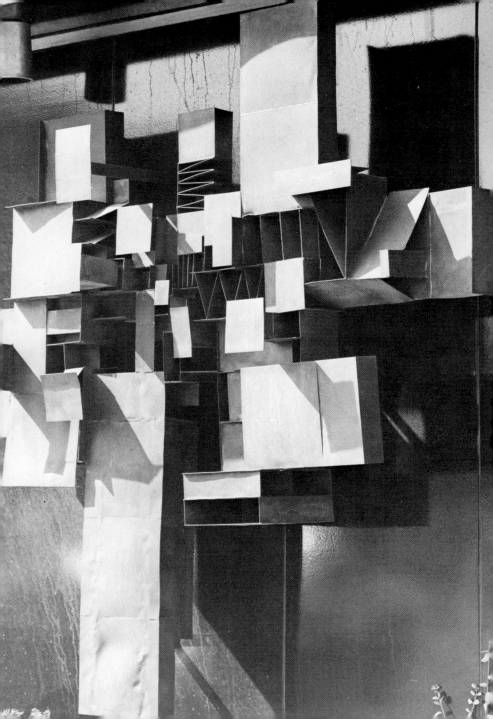

Corrado Joseph Parducci (1900-)
MICHIGAN BELL TELEPHONE RELIEFS
1941, limestone, 5'

Michigan Bell Telephone Building
220 N. Capitol Avenue, Lansing

Large spandrel reliefs articulate the Michigan Bell Telephone
Building which was designed by Smith, Hinchman & Grylls of
Detroit. From left to right they portray the farm, home, factory,
and office worker. The homey naturalism of the figural style
comes from the 1930s when the individual worker was emulated
for his social role in the community and the nation.

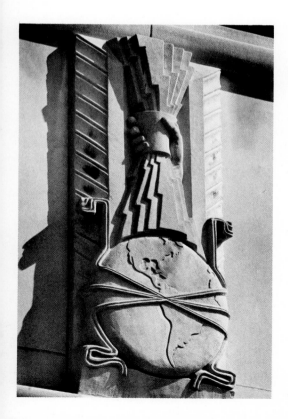

The logo over the entrance
illustrating humankind's
ability to control electricty
and transmit telephone calls
around the world employs
chevron and rectilinear
Art Deco motifs.

Corrado Joseph Parducci (1900-)
SUFFER THE LITTLE CHILDREN

1955, limestone, 7'

Children's Center, First Baptist Church
227 N. Capitol Avenue, Lansing

The sculptural relief on the tympanum of the doorway
to the Children's Center is a visualization of Jesus'
invitation to "suffer the little children to come unto
me" (Luke 18:16). The Children's Center was
constructed at the urging of Reverend Julius Fischbach,
pastor of the First Baptist Church from 1937 to 1961.
Reverend Fischbach, who received national recognition
for his Children's Church Program, stressed the
importance of children in the service and the need for
their own building. Designed by Lansing architect
Elmer Manson (1913-), this Children's Center was
realized through a gift of the Ramsom Eli Olds family,
longtime church members.

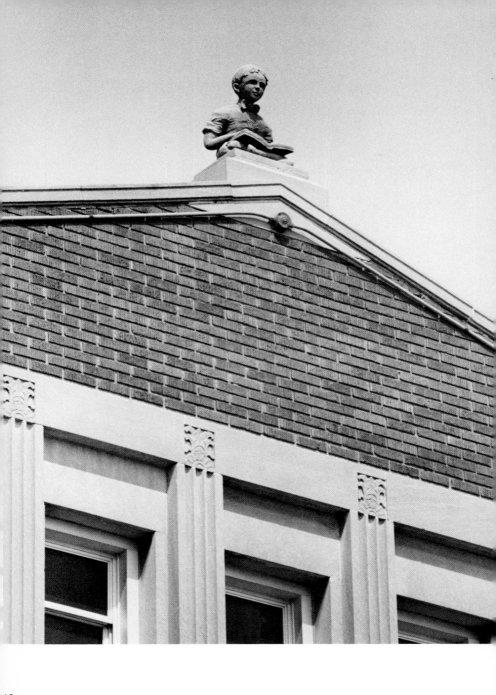

Artist Unknown
"BOY READING A BOOK"

1929, limestone, 31"

Education Building (West Junior High School)
500 W. Lenawee Street, Lansing

Ever since 1929 this little boy has been gazing out
over the city from the roof gable of the auditorium
which was added to West Junior High School by the
Lansing architect Judson Newell Churchill (1871-
1933). Neatly dressed in a bow tie and short pants,
this exemplary student is a reminder of the
educational activities that have taken place in this
building since it opened in 1919.

Samuel A. Cashwan (1900-)
OPEN CAGE

1966, copper-clad steel, 17′

Administration Building
Oldsmobile Division, General Motors Corporation
920 Townsend Avenue, Lansing

Open Cage was commissioned from Samuel Cashwan for Oldsmobile's new administration building. Cashwan's visual statement of corporate employment is expanded by his verbal statement: "This signifies people working in groups. They are in an open cage, free to leave their jobs at any time. The longer they stay, however, the closer their ties with the job and with their associates. Their roots grow deeper. The birds represent humans. They make gestures of flying, but never do."

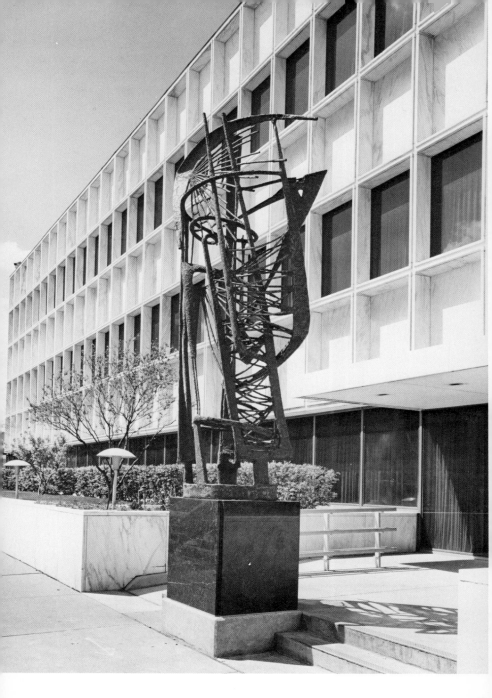

 Woody (Edwin W.) Sanford (1912-)
UNTITLED
1974, automobile parts, 22′

Story, Inc.
124 E. Kalamazoo Street, Lansing

Composed of Delta 88 automobile parts and painted red, this sculpture was designed for an Oldsmobile Factory Sales Outlet in New York but never reached its intended destination. Instead, it was erected behind the offices of Karl Story, an Oldsmobile dealer, in 1978. The sculpture was exchanged for support to Oasis Fellowship, Incorporated, a mental health organization in which Woody Sanford is involved. Sanford, who is dealing with the interrelatedness of surface and plane, feels that this work represents the industrial and cultural life of Lansing, home of the Oldsmobile.

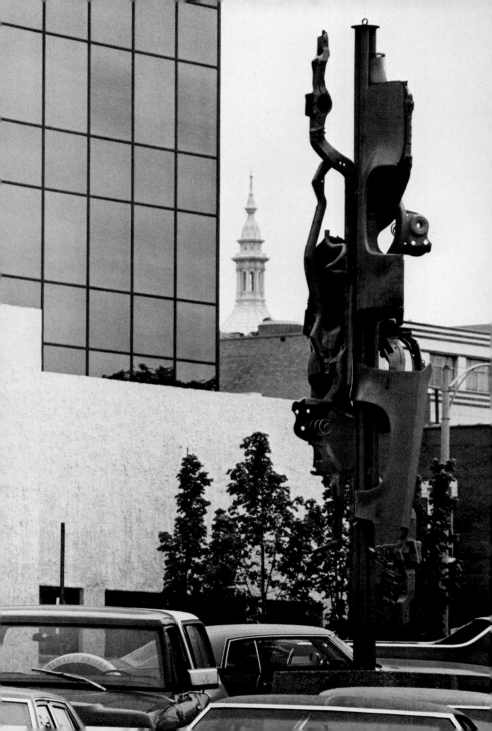

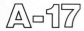

Samual A. Cashwan (1900-)
AQUARIUS

1938-1939, concrete, 32'

Water Conditioning Plant
148 S. Cedar Street, Lansing

This Art Deco building, designed by Lansing architects
Lee (1870-1960) and Kenneth C. (1901-) Black,
was constructed through the Works Progress
Administration. Related art works provided through
the Works Progress Administration, Federal Art Project
include an interior ceramic fountain, three murals, and
this facade relief sculpture. The monolithic figure of
Aquarius, the water bearer, carries a water pouch on
her shoulders and a turbine from which water pours
forth for her thirsty children, the City of Lansing.

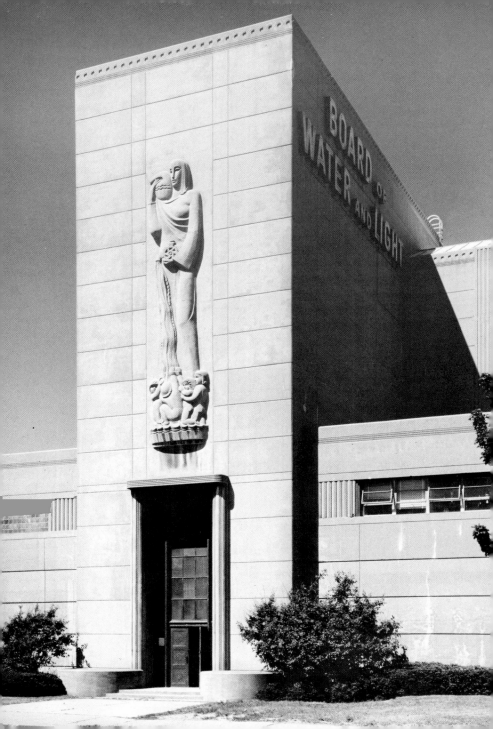

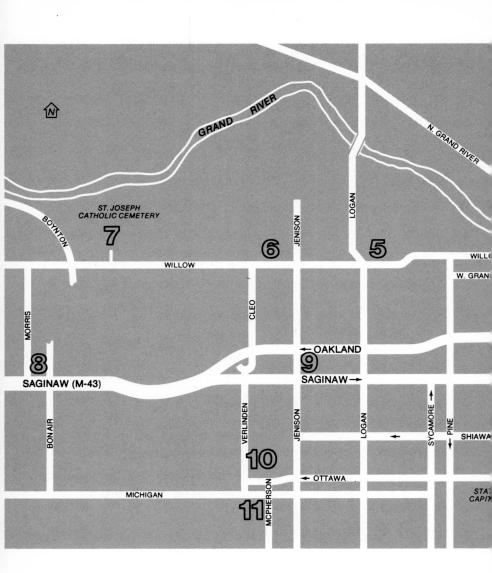

GRAND RIVER

N. GRAND RIVER

N

ST. JOSEPH
CATHOLIC CEMETERY

BOYNTON

LOGAN

JENISON

7

6

5

WILLOW

WILLO

W. GRAN

MORRIS

CLEO

8

← OAKLAND

9

SAGINAW (M-43)

SAGINAW →

BON AIR

VERLINDEN

JENISON

LOGAN

SYCAMORE

PINE

SHIAWA

10

← OTTAWA

MICHIGAN

MCPHERSON

STAT
CAPIT

11

RIVERBANK AND NORTHWEST

1. Martin Eichinger, WINDLORD
 Riverfront Park

2. Robert L. Weil, SALT SHED
 Riverfront Park

3. Joseph E. Kinnebrew IV, WILLIAM A. BRENKE RIVER SCULPTURE/FISH LADDER
 East Burchard Park

4. Tim Taylor, GEORGE
 Titus the Tinner

5. Leonard D. Jungwirth, THREE BEARS
 Willow Street School

6. Robert Ellison, UNTITLED
 Universal Steel Company

7. Charles O. Cooper, ASCENSION SHRINE
 Saint Joseph Catholic Cemetery

8. Robert James Forgrave, UNTITLED
 Professional Building

9. Frank C. Varga, SAINT FRANCIS
 Holy Cross Friary

10. H. James Hay, TREE OF AMERICA
 American Legion Headquarters

11. Corrado Joseph Parducci, J. W. SEXTON HIGH SCHOOL RELIEFS

5

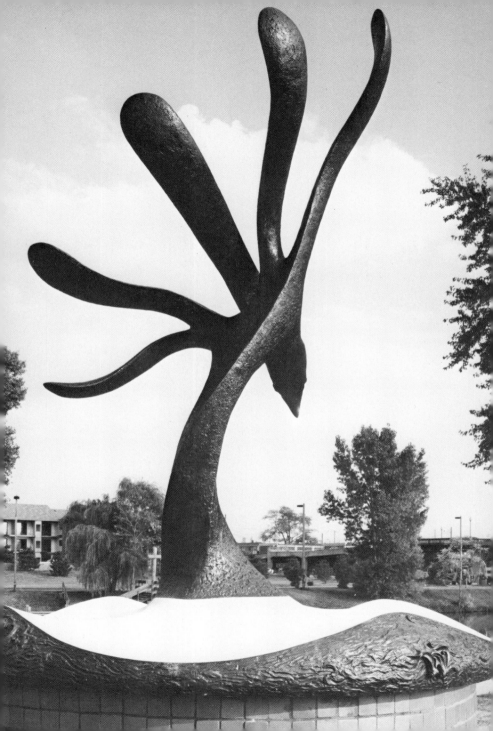

Martin Eichinger (1949-)
WINDLORD

1978, bronze, 12'6"
[M. Eichinger ©1978]

Riverfront Park
Grand Avenue between Shiawassee and Saginaw streets, Lansing

Stirred by criticism of José de Rivera's *Construction #150* (see
p. 29) and by a desire to stimulate dialogue between artists
and the city, Martin Eichinger proposed in 1975 that an eagle
sculpture be created for the bicentennial celebration. The
sculpture was ultimately commissioned by the City Council
in 1977 with funds provided by the Council, the Gannett
Foundation, the Comprehensive Employment and Training
Act (CETA), and a Community Development Grant.
Celebrating the power and dignity of the American eagle,
this semi-abstract work also refers to Gwahir, the Windlord
and mysterious saviour in Tolkein's Trilogy. The
simultaneous Windlord Media Project, developed by Joan
Stieber and funded by the Michigan Council for the Arts
and the East Lansing Community Cable Commission,
documented the construction of the sculpture and explored
the implications of this work which was created by a Lansing
artist with local monies.

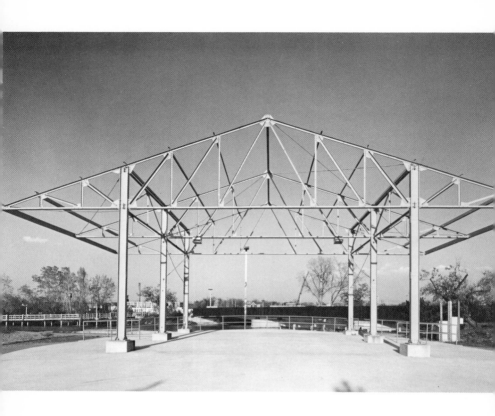

Robert L. Weil (1932-)
SALT SHED
1975-1976, steel, 30′

Riverfront Park
Grand Avenue between Shiawassee and Saginaw streets,
Lansing

This Bicentennial Park, dedicated on July 4, 1976,
was designed by O'Boyle, Cowell, Rohrer &
Associates, Inc., as part of an urban renewal project.
A portion of the city's former salt shed as well as the
nearby railroad and bridge were preserved and
integrated into this park which focuses on the Grand
River. Utilizing the trusses from the salt shed, Weil
has forged a new spatial design which is painted red.
The *Salt Shed* also functions as a performance area.

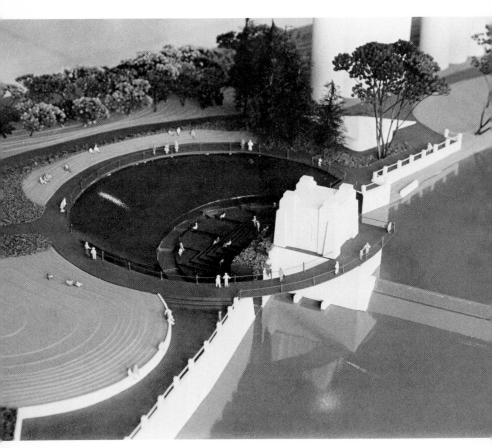

PHOTO: Michigan Department of Natural Resources

Joseph E. Kinnebrew IV (1942-)

WILLIAM A. BRENKE RIVER SCULPTURE / FISH LADDER

model 1979, concrete, basin diameter approximately 200'

East Burchard Park
E. Grand River Avenue at Turner Street, Lansing

This environmental work is a cooperative effort of Joseph
Kinnebrew, O'Boyle, Cowell, Rohrer & Associates, Inc., the
Michigan Department of Natural Resources, and the city of
Lansing. Funds have been provided by the latter two and the
United States Department of Interior. Scheduled to be
completed in 1980, it is part of a continuing effort to bring
people back to Lansing's riverfront. In this work, Kinnebrew
has integrated the natural water and land features and the
man-made dam and architectural structure into a new spatial
design. The circular rhythm of the land contour is repeated in
the reverse form of the basin and the squared, stepped
architectural form is echoed in the orderly repetition of the
stairs. Movement of both people and spawning fish will be in
circular and stepped patterns through the various water levels.
This site was originally the location of a log cabin and dam built
by Colonel John W. Burchard (1814-1844) in 1843. Burchard
intended to build a saw mill the following year, but died in a
spring flood while trying to repair a break in the dam. This site,
which bears Burchard's name, also honors Councilman William
A. Brenke, a catalyst in the realization of the project.

5

Tim Taylor (1950-)
GEORGE
1976, tin and fabric gloves, 4'6"

Titus the Tinner
2311 N. High Street, Lansing

This creative piece of folk art was combined with an antique pair of cast iron roofing shears (no longer extant) to advertise the products and services of this firm which was owned and managed by the Titus family until around 1970. Unlike the Tinman in the *Wizard of Oz,* this ever-friendly tinman has a heart which is carefully delineated with magic marker.

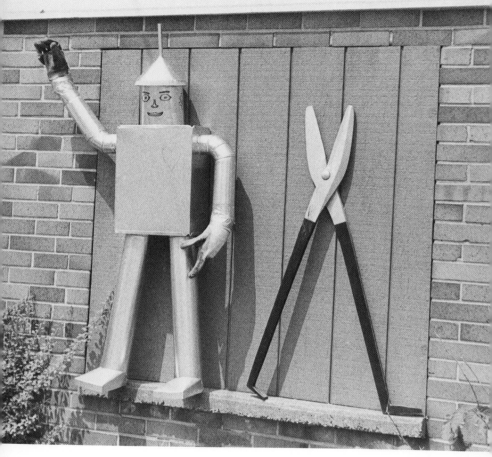

PHOTO: Fay L. Hendry

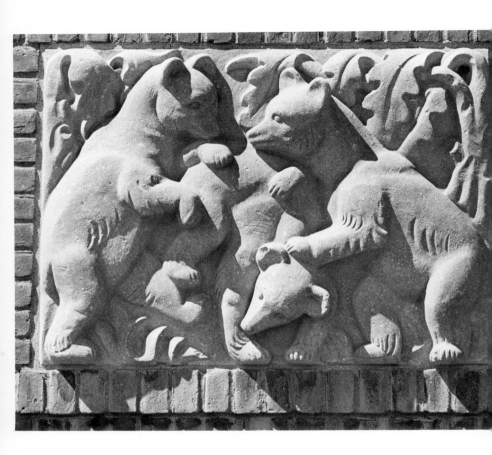

Leonard D. Jungwirth (1903-1963)
THREE BEARS
1953, limestone, 29"

Willow Street School
1012 W. Willow Street, Lansing

These playful bears were commissioned by Lansing
architect Elmer Manson (1913-) for an addition
to the new Willow Street School in 1953. The relief
was modeled by Leonard Jungwirth, who was
teaching sculpture at Michigan State College, now
known as Michigan State University. The sculpture
was moved to its present location when a second
addition was added to the elementary school around
1961.

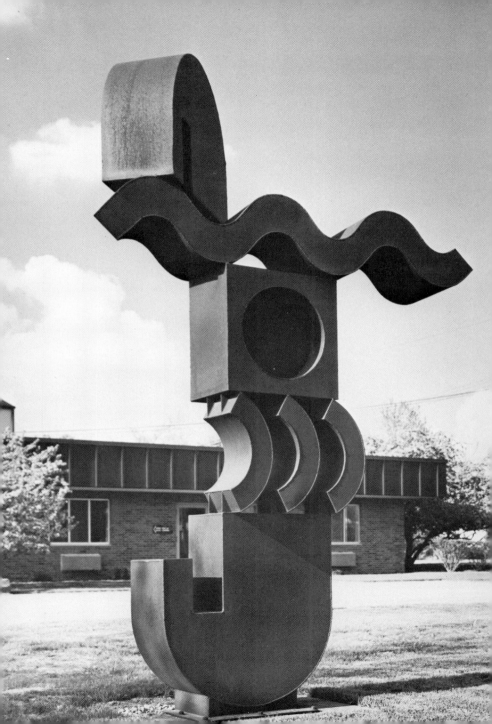

Robert Ellison (1946-)
UNTITLED

1970, cor-ten steel, 13'
[1970 R. Ellison]

Universal Steel Company
1800 W. Willow Street, Lansing

This work was created through a mutual exchange of goods and services. The sculptor, who was a student at Michigan State University, was allowed to experiment with a new material, cor-ten steel, and company employees were able to experience an alternate application of the material. In this playful sculpture, the heavy weight of the steel is challenged by the undulating, rhythmic, curving forms, and in particular, by the precariously balanced semi-circular form at the top.

Charles O. Cooper (1911-)
ASCENSION SHRINE

1969, bronze, 13'

Saint Joseph Catholic Cemetery
2520 W. Willow Street, Lansing

This elaborate shrine portrays Christ ascending to
heaven on a cloud with Mary and Saints James,
Peter, John, Paul and Matthew looking on. Included
in the shrine are the graves of several religious
leaders, an altar, and four granite monoliths which
arc toward the heart of Christ as a reminder that
one can ascend to heaven in the heart of Christ from
the four corners of the earth.

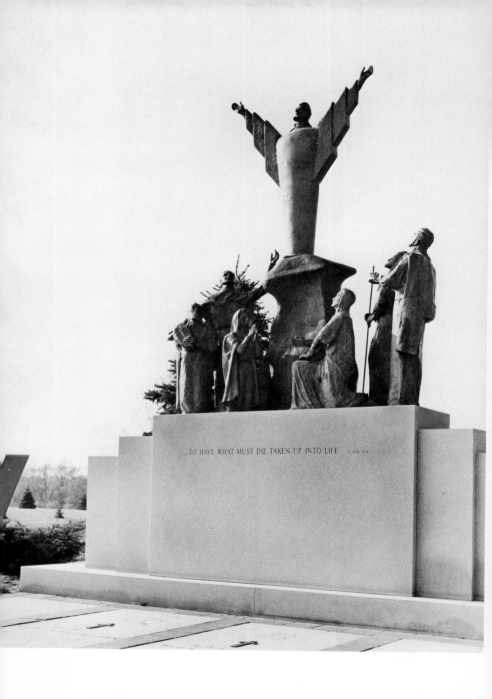

...TO HAVE WHAT MUST DIE TAKEN UP INTO LIFE 2 COR. 5:4

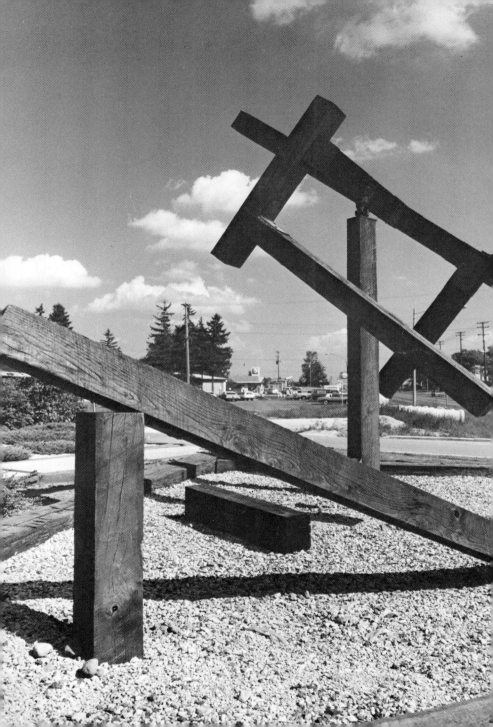

Robert James Forgrave (1955-)
UNTITLED
1978, wood and steel, 11'6"
[RJF logo]

Professional Building
3320 W. Saginaw Street, Lansing

Building upon the railroad tie motif which was already a
part of the site, Forgrave's sculpture progresses from a
small portion of a beam to the large kinetic construction
composed of dangling, thrusting beams. Not only does the
work change with the motion of the wind but it will
change through the weathering of the wooden beams and
the steel plates which join them. In this exchange between
owner and sculptor, the owner received a solution to a
site which originally contained a fountain and the sculptor
was provided with an opportunity to design and realize a
large, site-related sculpture.

Frank C. Varga (1943-)
SAINT FRANCIS

c. 1962, athena stone, 10′

Holy Cross Friary
1611 W. Oakland Avenue, Lansing

Holy Cross Parish was organized by Fathers from
the Franciscan Order, of which Saint Francis was the
founder. Saint Francis, who was dedicated to
poverty, chastity, and obedience, wears a brown
monk's robe and bears the stigmata or wounds of
Christ on his hands and feet. Cast in large simple
forms which suggest a cross, he is shown here
ministering even unto the birds.

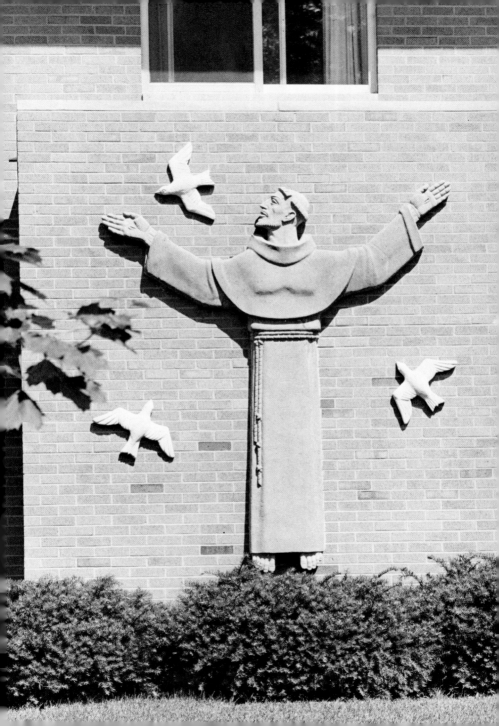

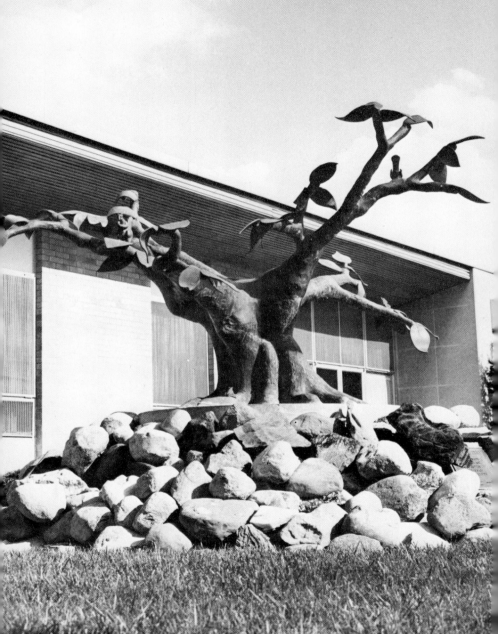

H. James Hay (1942-)

TREE OF AMERICA

1976, bronze, 8'

American Legion Headquarters
212 N. Verlinden Street, Lansing

Dedicated on July 10, 1976, *Tree of America* was commissioned by the American Legion, Department of Michigan, to celebrate the Bicentennial. The work was created by H. James Hay, a faculty member at Olivet College, and cast at the school's foundry. The tree is symbolically composed of thirteen roots (the original colonies), one trunk (the unified nation), five branches (the military branches), and fifty leaves (the states). The tree rises from a hill of two hundred fieldstones collected from Michigan's eighty-three counties. They refer to our two-hundredth birthday and to the ethnic diversity of the American Legion. The tree shelters several Michigan animals, including a turtle, frog, robin, bluejay, woodpecker, squirrel, and butterfly.

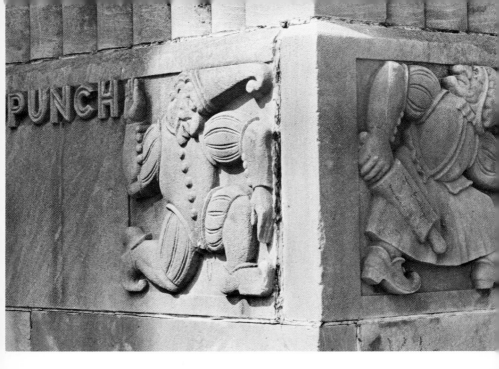

B-11

Corrado Joseph Parducci (1900-)
J. W. SEXTON HIGH SCHOOL RELIEFS
1941, limestone, PUNCH AND JUDY 18"

J. W. Sexton High School
102 McPherson Street, Lansing

This high school was designed by the Warren Holmes Company of Lansing and constructed with the aid of the Public Works Administration. By naming the school after Dr. J. W. Sexton, a longtime teacher and administrator, the Board of Education established a new precedent, though not without controversy, for naming a school after a living person. Much of the building is coverd with square or rectahgular sculptural reliefs which illustrate such activities as sewing, cooking, shop, biology, chemistry, physics, literature, writing, football, basketball, music, art, and drama. Drama is also symbolized by the English theater puppets Punch and Judy which are located near the auditorium steps.

SOUTHEAST

1. Peter Toth, INDIAN MONUMENT
 Potter Park

2. Jack Bergeron, LONGFORM
 Impression 5 Museum

3. Dale Johnson, UNTITLED
 Impression 5 Museum

4. Artist Unknown, "OWL IN A TREE TRUNK,"
 LONGSTREET MONUMENT
 Mt. Hope Cemetery

5. Leonard Crunelle, DR. GEORGE E. RANNEY RELIEF
 Mt. Hope Cemetery

6. Artist Unknown, "WOMAN CLINGING TO A CROSS,"
 RIX MONUMENT
 Mt. Hope Cemetery

7. Edith Barretto Stevens Parsons, FISH BABY
 Evergreen Cemetery

C-1

Peter Toth (1947-)
INDIAN MONUMENT
1975, wood, 30′

Potter Park
1301 S. Pennsylvania Avenue, Lansing

In the summer of 1975, Peter Toth offered to carve and
give to the City of Lansing and her people an Indian
Monument if materials and services were provided.
Initially, the city was reluctant to accept his gift, but
eventually with private donors did provide materials and
services. The simply carved Indian, with large
exaggerated features, was carved out of an elm tree and
is intended to both honor the native American Indian
and to bring attention to his plight. It is the fifteenth in
Toth's projected goal to place an Indian Monument in
each state.

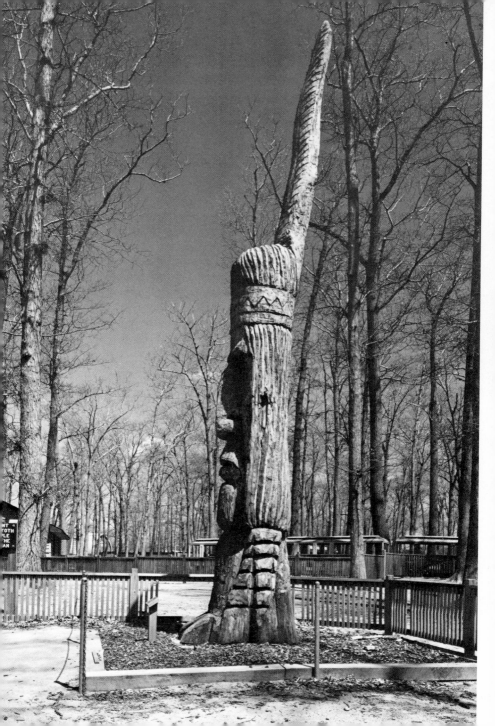

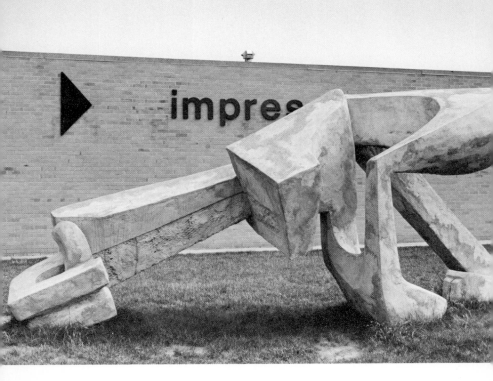

Jack Bergeron (1950-)
LONGFORM

1976, ferrocement, 7'4"

[Bergeron 76]

Impression 5 Museum
1400 Keystone Drive, Lansing

Longform was created for *From the Bottom Up: 15
Contemporary Michigan Sculptors,* a grassroots
exhibition held in 1976 under the auspices of the
East Lansing Fine Arts and Cultural Heritage
Committee. Works were sited throughout the
community and this sculpture was subsequently
purchased with private funds for the Impression 5
Museum. Visitors to the museum, which explores
the five senses through art, science, and technology,
can touch, walk around, or climb on the interlocking
organic and mechanical forms.

Dale Johnson (1947-)
UNTITLED

1976, steel, 18′

Impression 5 Museum
1400 Keystone Drive, Lansing

Johnson created this work as a personal expression
and later gave it to the Impression 5 Museum, a
museum which explores art, science, and technology.
Made of "drops" from a local steel company, Johnson
used his "finds" to spontaneously construct this
whimsical sculpture. To add to the whimsicality,
some of the parts are brightly painted while others
dance in the wind or move when climbed upon.

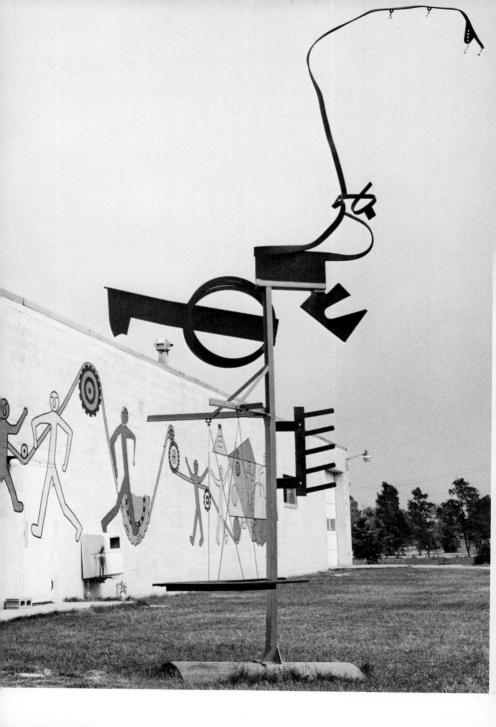

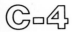

Artist Unknown

"OWL IN A TREE TRUNK," LONGSTREET MONUMENT

date unknown, limestone, 10'5"

Mt. Hope Cemetery
1709 E. Mt. Hope Road, Lansing

The dead tree trunk juxtaposed with living ivy or other plants was a popular funerary motif in the latter part of the nineteenth and early part of the twentieth centuries. The motif symbolizes the cycle of birth and death. In the Longstreet monument an additional death reference may be made by the owl, a creature of the darkness. The insignia at the base of the monument refers to William Longstreet's service in the United States Army Corps of Engineers from 1862 to 1865. The inscription on the trompe l'oeil "peeled" strip of bark indicates that Clarence, son of William (1830-1895) and Caroline (1835-1900), lived briefly from January 25, 1862, to January 11, 1863. Smaller stumps are placed around the family monument for individual family members.

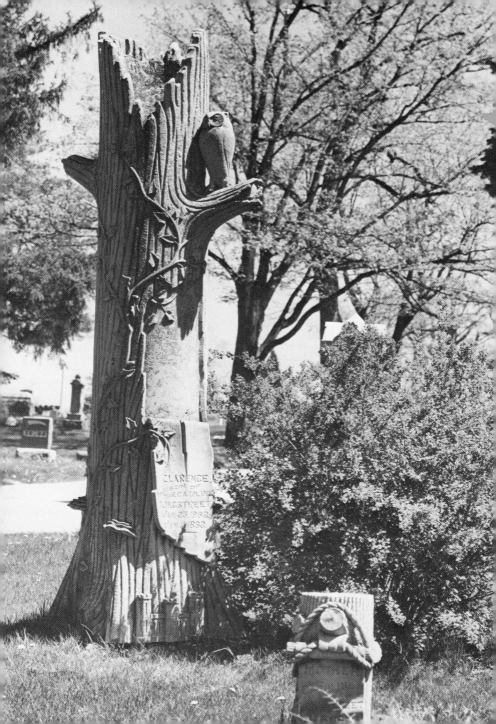

CLARENCE
SON OF
W. & CAROLINE
LONGSTREET
Jan 25, 1882
Jan 11, 1883

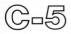

Leonard Crunelle (1872-1944)
DR. GEORGE E. RANNEY RELIEF

c. 1914, bronze, 19"
[Leonard Crunelle Sc Cast by J. Berchem, Chicago, Ill.]

Mt. Hope Cemetery
1709 E. Mt. Hope Road, Lansing

According to the will of Dr. George E. Ranney (1839-1915), this Scipio sarcophagus was designed and bronze reliefs were commissioned from the Chicago sculptor Leonard Crunelle in 1914. The Scipio sarcophagus, so-called because it is patterned after that of the Roman general Lucius Cornelius Scipio Barbatus, was popular in cemeteries in the United States. The main relief on the monument contains Ranney's portrait and details of his long life of service, including surgeon in the Civil War, founder and later president of the Michigan Medical Society, and discoverer of the cause of typhoid fever. A smaller relief on the east end of the monument indicates that Ranney was awarded the Bronze and Gold Congressional Medals of Honor. Ranney's will also details his bequest for the George E. Ranney Playground and Park "for the increase of physical education and mental culture." His gift reflects the increasing interest in recreation after the turn of the century.

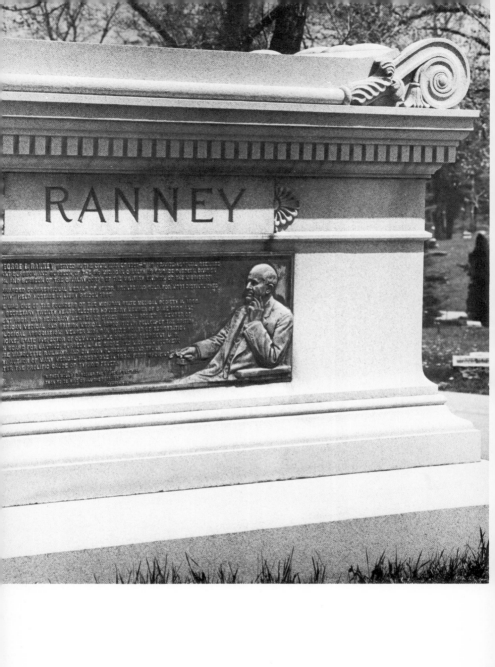

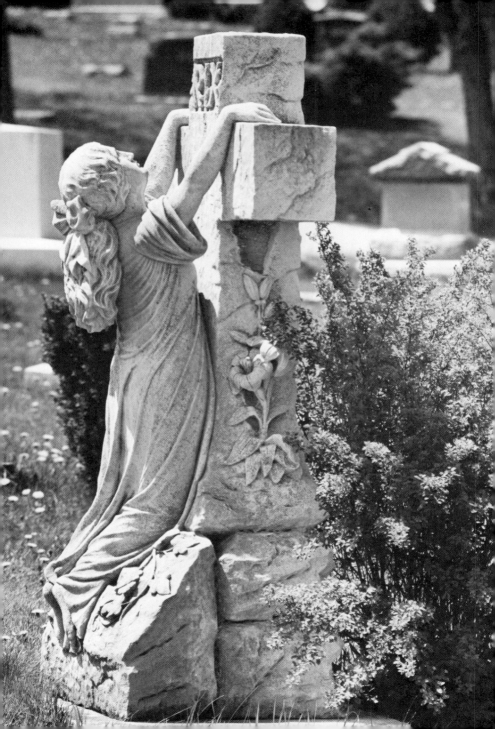

Artist Unknown

"WOMAN CLINGING TO A CROSS," RIX MONUMENT

date unknown, limestone, 6'2"

Mt. Hope Cemetery
1709 E. Mt. Hope Road, Lansing

The mourning female, an ancient symbol of grief, is sentimentally interpreted in this cemetery monument which may have been erected following the death of Charlotte B. Rix (1865-1929). The youthful figure, whose body arcs toward the cross, and the ivy and lilies refer to the pure and everlasting life that begins in heaven.

Edith Barretto Stevens Parsons (1878-1956)
FISH BABY

c. 1915-1920, bronze, 40"
[Roman Bronze Works N.Y. E. B. Parsons]

Evergreen Cemetery
2500 E. Mt. Hope Road, Lansing

This fountain was privately placed in the cemetery in
1948, though the sculpture was likely modeled
somewhat earlier. Parsons, who created busts,
memorials, and other kinds of sculpture, was particularly
known for her fountains of babies and animals. This
fountain is typical of the garden sculpture which was
popular in the earlier part of the century when a new
class of patrons began to place sculpture in their private
gardens. Appropriate for this cemetery-park setting, the
curled toes and lilt of the head convey a sense of
profound joy.

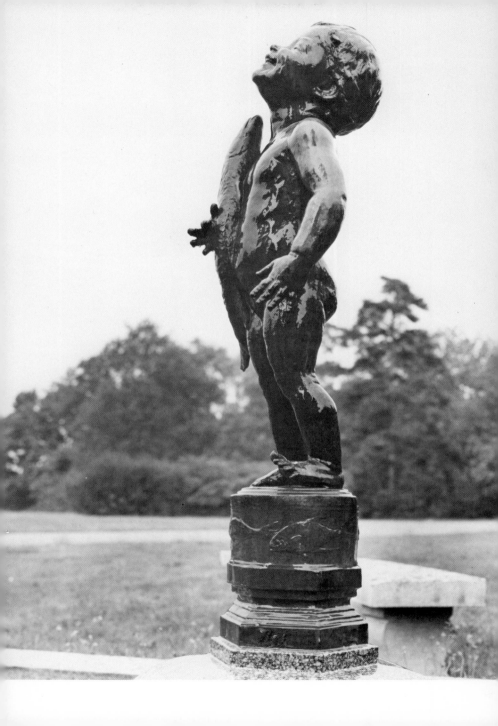

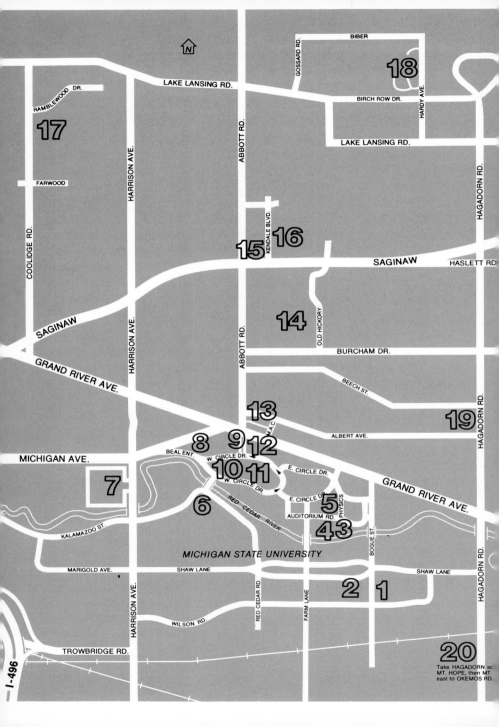

MICHIGAN STATE UNIVERSITY/ EAST LANSING AREA

Michigan State University

1. Melvin G. Leiserowitz, UNTITLED

2. Subrata Lahiri, METAMORPHOSIS II

3. James Wolfe, MADNESS OF THE GOLDFISH

4. Jerald W. Jackard, UNTITLED

5. Carl L. Schmitz, PHYSICS AND ASTRONOMY BUILDING RELIEFS

6. Leonard D. Jungwirth, SPARTAN

7. Doris Hall and Kalman M. B. Kubinyi, AQUARIUS, ARIES, PISCES

8. Clivia Calder Morrison, CHILDREN READING

9. Samuel A. Cashwan, ABBOTT ROAD ENTRANCE MARKER

10. Samuel A. Cashwan, "THREE MUSICIANS"

11. Lee Lawrie, THE SOWER

12. Samuel A. Cashwan, PROMETHEUS

East Lansing Area

13. Thomas E. Young, UNTITLED *Allé*

14. Melissa Williams, ASCENSION *East Lansing High School*

15. Aharon Bezalel, MAN AND HIS CITY *241 Building*

16. William J. Heusted, EMBRACE *Michigan Education Association*

17. Aharon Bezalel, UNTITLED *Congregation Shaarey Zedek*

18. Robert L. Weil, UNTITLED *Edgewood Village Children's Center*

19. John T. Scott, PIETÀ *Edgewood United Church*

20. Artist Unknown, CHIEF OKEMOS MEMORIAL TABLET *Central School*

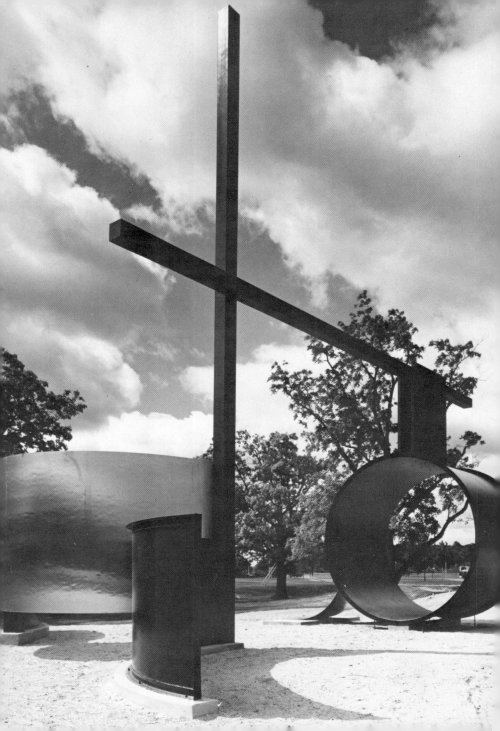

Melvin G. Leiserowitz (1925-)
UNTITLED

1979, cor-ten and stainless steel, 35'

State Center for the Performing Arts, Michigan State University
Bogue Street, between E. Shaw Lane and Wilson Road

This untitled sculpture was commissioned by Michigan State University's Board of Trustees and dedicated on May 25, 1979. Former President Clifton R. Wharton, Jr., provided the money from fees earned while serving on the boards of directors of Ford Motor Company and Burroughs Corporation. Created by faculty member Melvin Leiserowitz, this environmental sculpture with its silver and black surfaces will focus on the performing arts center designed by Caudill, Rowlett, and Scott of Houston, Texas. Playing upon the circles, curves, and right angles of the building, this visual relationship will be heightened by viewing the building through its sculptural frame, or by viewing the sculpture and the transitional grove of trees through the windows of the elevated lobbies. As a piece which can be walked through, the sculpture becomes a performance in itself.

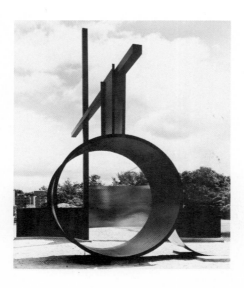

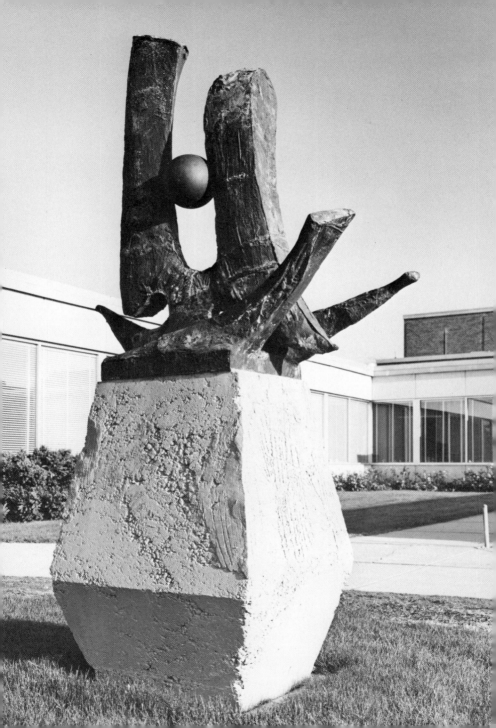

Subrata Lahiri (1932-)
METAMORPHOSIS II
c. 1966, bronze, 5'2"

Cyclotron Laboratory, Michigan State University
S. Shaw Lane near Bogue Street, East Lansing

Metamorphosis II has itself been metamorphosed in both
title and substance since it was first placed in front of the
Cyclotron in 1965. Created by a former student and
cyclotron employee, this work was originally in plaster
and titled *The Last Word.* Cast in bronze about a year
later, this sculpture suggests the workings of the
cyclotron in which atoms are changed into electrified
particles and accelerated in a magnetic field. In
commenting on the nature of change, the open part at the
top signifies the past, the center the present, and the
closed part at the bottom the future, in which death has
the last word. *Metamorphosis I* is located at Tokoyo
University and *Metamorphosis III* is at the University of
Arkansas where Subrata Lahiri is currently teaching.

James Wolfe (1944-)
MADNESS OF THE GOLDFISH

1974, steel, 33"

Kresge Art Gallery, Michigan State University
Auditorium and Physics roads, East Lansing

A gift to Kresge, this piece was created for a show at
the Andre Emmerich Gallery in New York. For this
show, James Wolfe moved away from his more spidery,
vertical works toward dense floor pieces with curved
planes. Wolfe soon found that he had madly piled too
much into these pieces and began to remove parts until
this "goldfish" form emerged. Wolfe now refers to this
series as travois, after the travois pulled behind horses
by the American Indian.

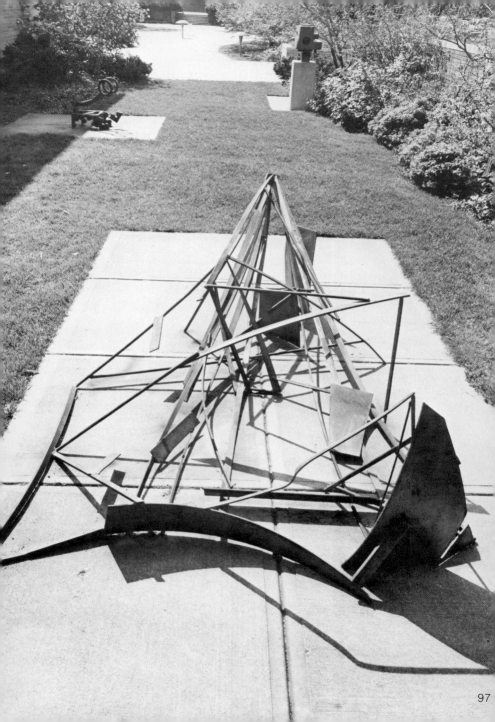

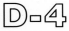

Jerald W. Jackard (Jacquard) (1937-)
UNTITLED

1965, steel, 26"

Kresge Art Gallery, Michigan State University
Auditorium and Physics roads, East Lansing

This small untitled sculpture, with smooth black
surfaces, was created by a former MSU student and
purchased by the Michigan State University
Development Fund in 1966. Though this minimalist
work suggests industrial impersonalization, it also
suggests organic growth with its voids and bulging
projections.

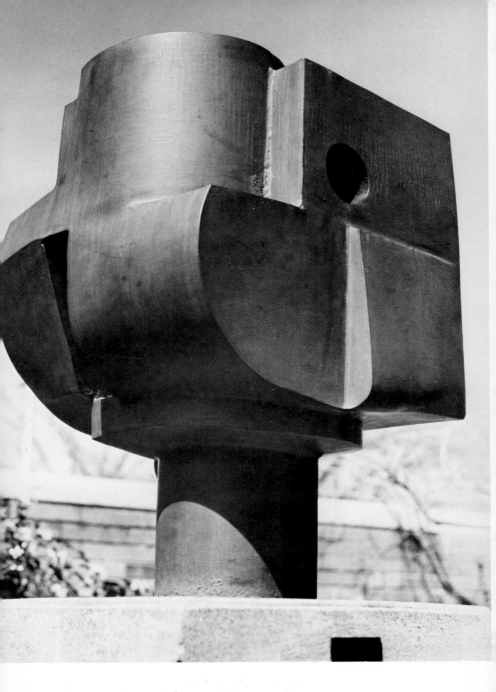

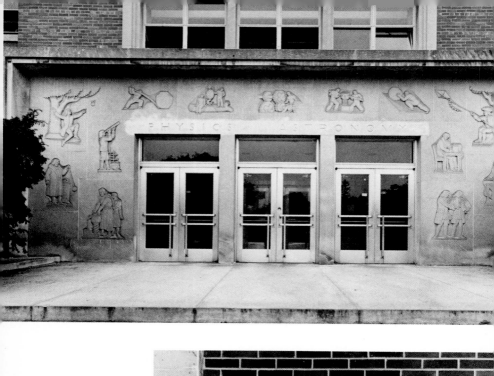

Carl L. Schmitz (1900-1967)

PHYSICS AND ASTRONOMY BUILDING RELIEFS

1947, limestone, HELMHOLTZ AND MICHELSON 6′
[C. L. SCHMITZ, SC. DES.]

Physics and Astronomy Building (Physics and Mathematics Building)
Michigan State University
Physics and Dormitory roads, East Lansing

These reliefs, relating the story of physics and mathematics, were created by New York sculptor Carl Schmitz during his brief teaching stint at Michigan State College (now Michigan State University). They employ a broad 1940s style and are executed in a sunken relief technique akin to Egyptian wall reliefs. Newton, who supposedly studied gravity by observing a falling apple, is at the upper left. Below is Galileo who conducted experiments with the pendulum and reportedly observed the speed of falling objects from the Tower of Pisa. To the right is Archimedes who observed that King Hieron's crown was displaced by an equal amount of water. Above Archimedes can be found Huygens who played a role in the development of the telescope. Above the door from left to right are various simple machines: the lever, pulley, gear, screw, and inclined plane. Franklin, who used a kite to experiment with electricity, is at the upper right. Below, the seated Faraday is observing a cell through which an electric current is passing. Beneath him are Leibnitz and Newton, who independently of one another invented calculus. At the lower right is Oersted who is demonstrating the magnetic effect of an electric current. The relief at the southeast entry refers to the discovery of x-rays and shows the standing Roentgen and seated Crookes each holding a tube named in his honor. The relief at the northeast entry shows Einstein, known for his theories of relativity, standing in front of the cyclotron which was invented by Lawrence. The relief by the north entry (see detail) shows Helmholtz holding a resonator to his ear to amplify sound from a tuning fork and Michelson, who measured the velocity of light, looking through a telescope at an eight-sided mirror. The transmission of radio waves is the subject of the relief at the southwest entry and portrays Marconi standing near Maxwell.

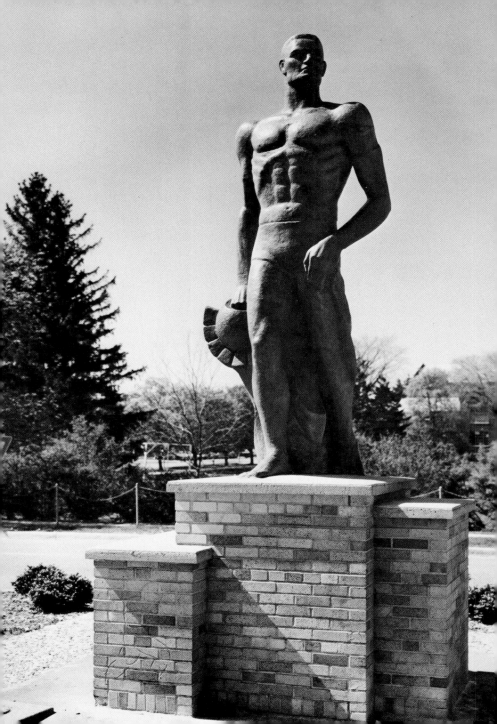

Leonard D. Jungwirth (1903-1963)

SPARTAN

c. 1944, terra cotta, 10'6"

[_ _ _ ired by Grand Ledge Clay Products Co. _ _ _ _ ptor]

Michigan State University
Kalamazoo Street and Red Cedar Road, East Lansing

The name of the team players at Michigan Agricultural College was the Aggies until it was changed to the Spartans in 1926. In the early 1940s, faculty member Leonard Jungwirth was asked to model a Spartan warrior for the gateway to the athletic complex. The dedication speech was delivered by President John A. Hannah on June 9, 1945, and true to his predictions, "Sparty" has become a symbol for what is known today as Michigan State University. This monumental statue is based on the spirited warriors of ancient Sparta and the ideal Greek form which is reinterpreted here in an angular Art Deco style. The statue was fired at the nearby Grand Ledge Clay Products Company and is billed as one of the world's largest freestanding ceramic sculptures. On the base of the sculpture are incised figures which represent the various sports played on campus.

Doris Hall (1907-)
Kalman M. B. Kubinyi (1906-1973)
AQUARIUS, ARIES, PISCES
1956, enamel, c. 12'

Butterfield and Emmons Halls, Michigan State University
Harrison Road and Michigan Avenue, East Lansing

When the Brody Dorm Complex was designed by Detroit architect Ralph Calder (1894-1969), this husband-wife artistic team was commissioned to create the twelve signs of the zodiac for the large wall areas on each dormitory. The project was abandoned after the first three sculptures were hung because of an unfavorable reception. Controversy centered in part around the use of bright colors and, at the time, the unorthodox subject matter. Dramatic in scale and color, these works illustrate a bold use of the ancient enameling technique.

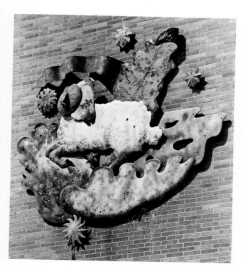
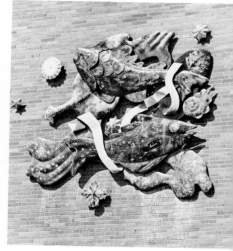

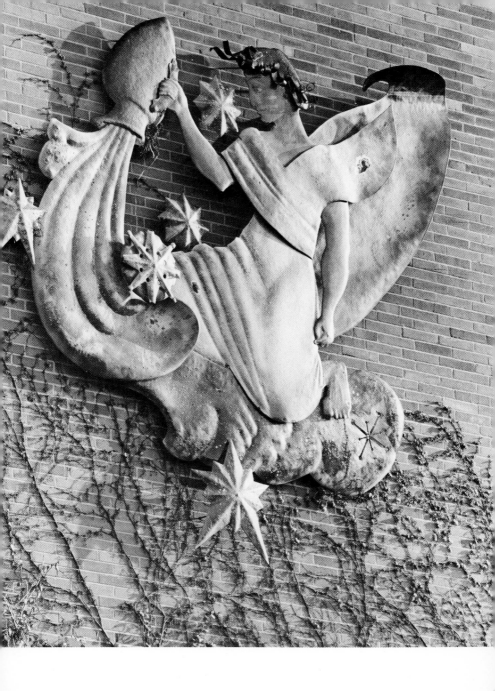

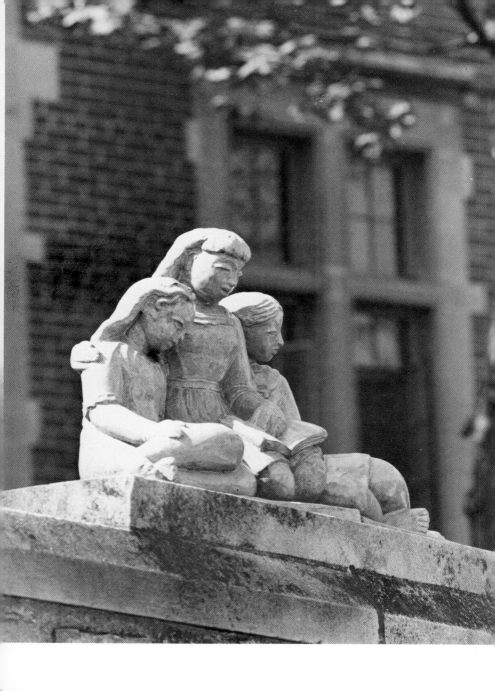

Clivia Calder Morrison (1909-)
CHILDREN READING
c. 1938, terra cotta, 19″
[Clivia '3 ?]

Sarah Langdon Williams Hall, Michigan State University
Beal Street Entrance and Michigan Avenue, East Lansing

The sculptural group on the garden wall and the fish
head spout on the fountain below are made of glazed
blue clay. They were completed through the Works
Progress Administration, Federal Art Project, for
this women's dorm which was designed by Detroit
architect Ralph Calder (1894-1969). These sloe-eyed
little girls who are reading a book symbolize
education.

Samuel A. Cashwan (1900-)
ABBOTT ROAD ENTRANCE MARKER
1938-1939, limestone, 9'9"

Michigan State University
Abbott Road and Grand River Avenue, East Lansing

A gift of the Class of 1938, this welcoming marker was
placed at one of the main entrances to Michigan State
University, formerly known as Michigan State College
of Agriculture and Applied Science. Created through
the Works Progress Administration, Federal Art
Project, it symbolizes the various educational
opportunities available to the youthfully portrayed
students. The horse refers to agriculture, the wheat to
agriculture and home economics, and the fluted column
to the cultural arts and the dignity and stability of the
college.

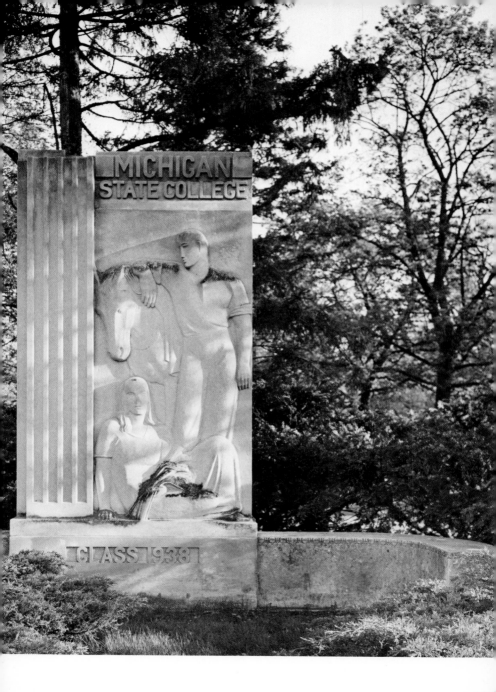

Samuel A. Cashwan (1900-)
"THREE MUSICIANS"

c. 1940, concrete, 7'3"

Music Building, Michigan State University
W. Circle Drive, East Lansing

One of a pair, this angular sculptural group was originally
created around 1940 for the left side of the Band Shell at
Michigan State. This streamlined 30s amphitheater was made
possible through a gift of the Class of 1937 and the Works
Progress Administration, Federal Art Project. Designed by
Lansing architect O. J. Munson (1891-1957) of Bowd-Munson
and dedicated on May 11, 1938, the Band Shell was used for
cultural activities like concerts, plays, fraternity and sorority
sings, and even graduation. When it was torn down in 1959 to
make way for Bessey Hall, this sculptural group was salvaged
and appropriately placed near the music building.

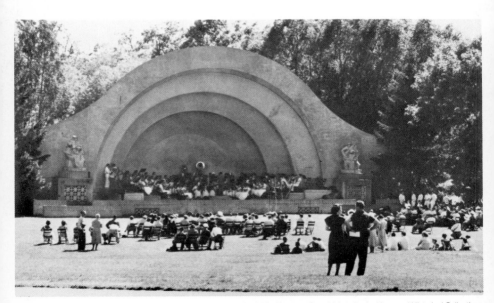

PHOTO: Michigan State University Archives and Historical Collections

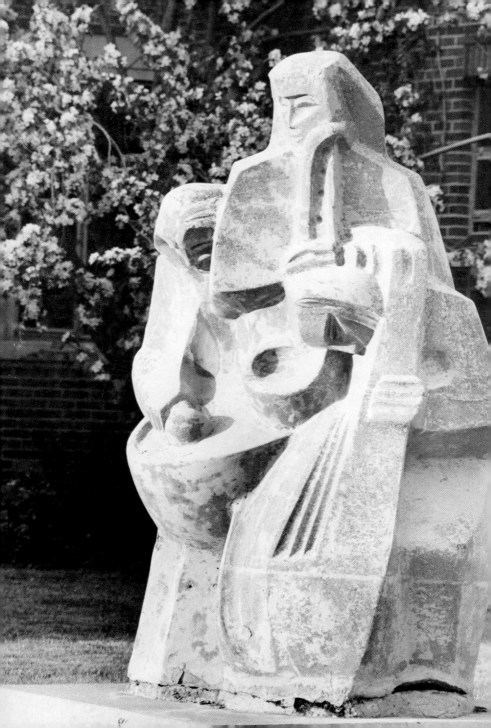

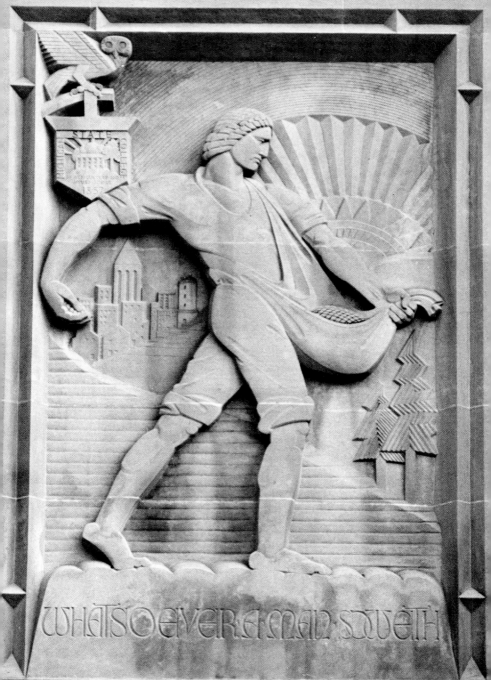

WHATSOEVER A MAN SOWETH

Lee Lawrie (1877-1963)
THE SOWER
c. 1929, limestone, 10'6"

Beaumont Memorial Tower, Michigan State University
W. Circle Drive, East Lansing

Beaumont Tower is the gift of John W. Beaumont, class of 1882, and his wife, in gratitude for the inspirational education that he received as a student. It also memorializes the site of old College Hall where scientific agriculture was first taught in the United States. Designed by Detroit architect John M. Donaldson (1854-1941) and equipped with the bronze bells of a carillon, this Gothic campanile was dedicated on June 22, 1929. The site of concerts and other events, Beaumont Tower and *The Sower* symbolize the planting of agricultural and educational seeds. Beneath this crisp Art Deco relief, which was modeled by New York sculptor Lee Lawrie, is the biblical inscription "Whatsoever a man soweth."

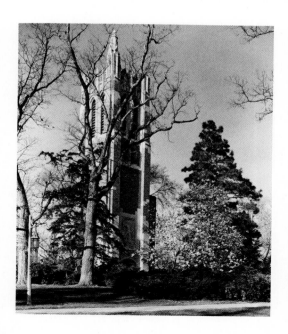

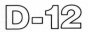

Samuel A. Cashwan (1900-)
PROMETHEUS
1948, limestone, 3'3"

Union Building, Michigan State University
Abbott Road and W. Circle Drive, East Lansing

The Union Building at Michigan State University
was begun by alumni in 1924 as a memorial to all
former graduates who had served and lost their lives
in previous wars. In 1948 the Union received a new
south wing designed by Detroit architect Ralph
Calder (1894-1969) who arranged for Samuel
Cashwan to carve this relief over the door.
Prometheus, who brought fire and the arts of
civilization to mankind, serves as inspiration to
Music, Drama, Sculpture, Research, Science, and
Agriculture.

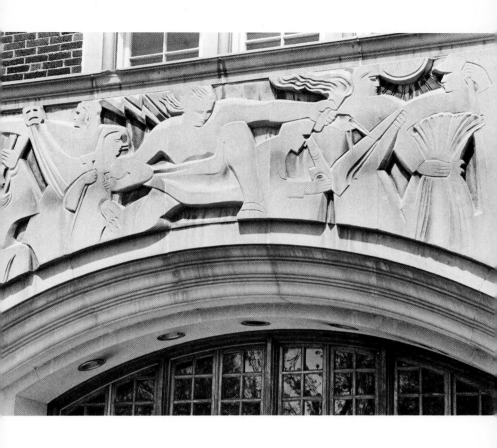

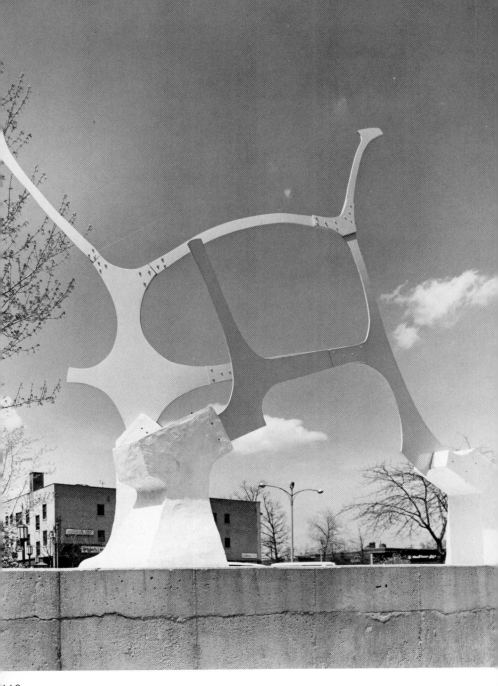

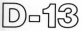

Thomas E. Young (1941-)
UNTITLED

1976, steel and concrete, 18'
[Young '76]

Allé
between Abbott Road and MAC, East Lansing

This piece was created for the 1976 exhibition *From the Bottom Up.* Upon the recommendation of the East Lansing Fine Arts and Cultural Heritage Committee, who sponsored the grassroots exhibition, the piece was purchased with private funds for the city. Contrasting with its builky concrete supports, the orange tendril-like forms, some of which are not completed, reach toward the sky like grafted branches on a tree. Created during the Bicentennial celebration, these forms rise up in the air as an inspiration to the future.

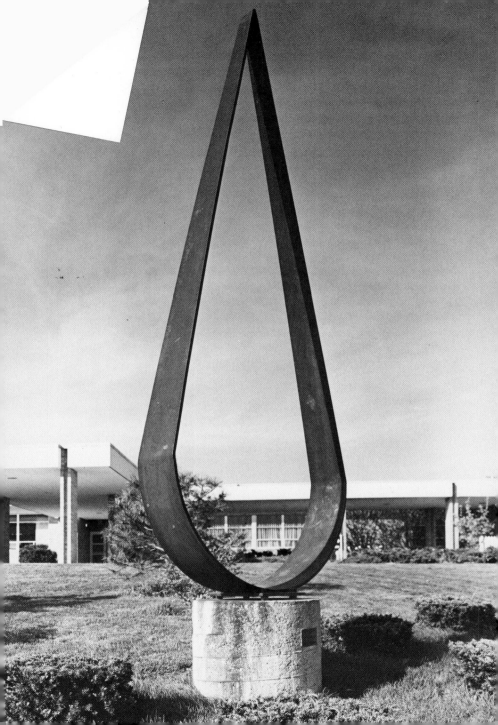

D-14

Melissa Williams (1940-)
ASCENSION
1976, steel, 12'
[M W 1976 logo]

East Lansing High School
509 Burcham Street, East Lansing

As part of its Bicentennial celebration, the East Lansing
School District held a design competition among its art
teachers for a sculpture to mark the site of a time capsule.
Melissa Williams won the contest and dedicated her
sculpture to the Native American on October 17, 1976.
Williams is a descendant of George Catlin (1796-1872),
the American Indian painter. This simple teardrop form
suggests a coming together and an upward movement.
The capsule, which contains the original drawing by
Williams and items selected by each school in the
district, is sealed for one hundred years and will be opened
in 2076.

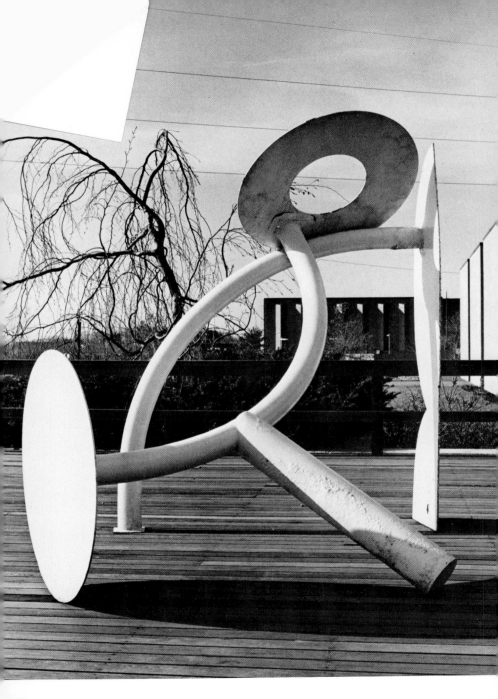

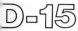

William J. Heusted (1948-)
EMBRACE
1977, steel, 6'7"
[WJH]

Michigan Education Association
1216 Kendale Boulevard, East Lansing

Embrace was exhibited in the Michigan Education Association's 13th Annual Art Exhibition, a show which features art by Michigan teachers. William Heusted was a graduate assistant at Michigan State University at the time and his work received both a special mention and the MEA Purchase Prize. Now a part of the growing MEA collection, this piece is composed of yellow curving and related forms which suggest ways that people can reach out, touch, and relate to each other.

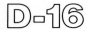

Aharon Bezalel (1926-)
MAN AND HIS CITY

1970, aluminum, 30′

241 Building (Alco Building)
241 E. Saginaw Street, East Lansing

While visiting Aharon Bezalel's studio in Jerusalem, Alan Ginsburg commissioned this sculpture for his new Alco Building. A skyscraper form tucked full of tiny city dwellers, the sculpture reflects the artist's impressions of New York City and symbolizes twentieth century urban life. The sculpture also emphasizes the form of the building behind it and the human activity within.

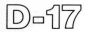

Aharon Bezalel (1926-)
UNTITLED
1968-1969, bronze, 18', tablets, 3'

Congregation Shaarey Zedek
1924 Coolidge Road, East Lansing

Commissioned for the new synagogue, this expressive arch is formed of figures who exultantly hold aloft the menorah or seven-branched candelabrum. Aharon Bezalel, an Israeli sculptor, has purposefully contrasted this work with a relief on the Arch of Titus (A.D. 81) which shows Roman soldiers in triumphal procession bearing the spoils of the Temple, including the menorah. The menorah symbolizes the eternal light of the Jewish faith and the law tablets in the background remind the worshipper that by obeying God's laws he will be a light unto himself and others. Displayed in Jerusalem before the dedication on August 22, 1969, this work invites all to walk through the arch and experience this sculpture.

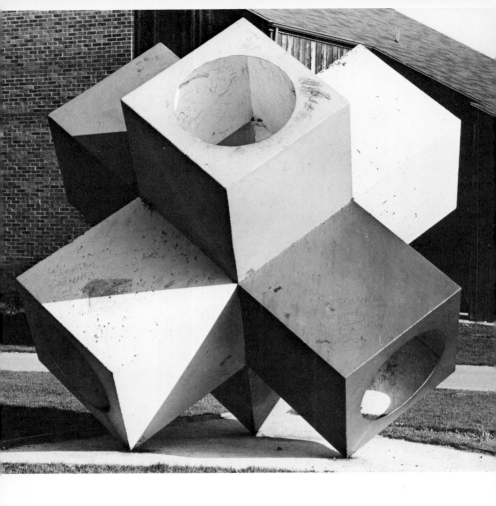

Robert L. Weil (1932-)
UNTITLED

1974, steel, 12′

Edgewood Village Children's Center
6223 Towar Gardens Circle, East Lansing

This play sculpture was created for Edgewood Village, a low-cost housing development initiated by Edgewood United Church through the State Housing Development Authority. The inspiration for the sculpture came from a Tibetan Yantra Mandala composed of nine squares which is used for meditation. When concentrated upon, the geometrical design appears to rotate from the center. This optical and spatial effect is repeated in the sculpture and can be particularly experienced when climbing inside. Designed to stimulate both mental and physical development, these elemental cubes are painted the primary colors of red, yellow, and blue.

John T. Scott (1940-)
PIETÀ

c. 1965, bronze, 32″

Edgewood United Church
469 N. Hagadorn Road, East Lansing

The pietà, which first appeared in Germany around the
fourteenth century, portrays Mary mourning over the
dead Christ in her lap. John T. Scott's thoughts about
this theme and about the pain of death on the living
were brought to focus by a newspaper photograph of
Mrs. John F. Kennedy holding the head of the
assassinated President in her lap. Scott, who was a
student at Michigan State University at the time,
responded to the photograph by creating this pietà in
swelling curvilinear forms. The work was later cast in
bronze as a memorial to Martin S. Soria. Soria, a
Professor of Art History and member of Edgewood
United Church, died in a plane crash in 1961.

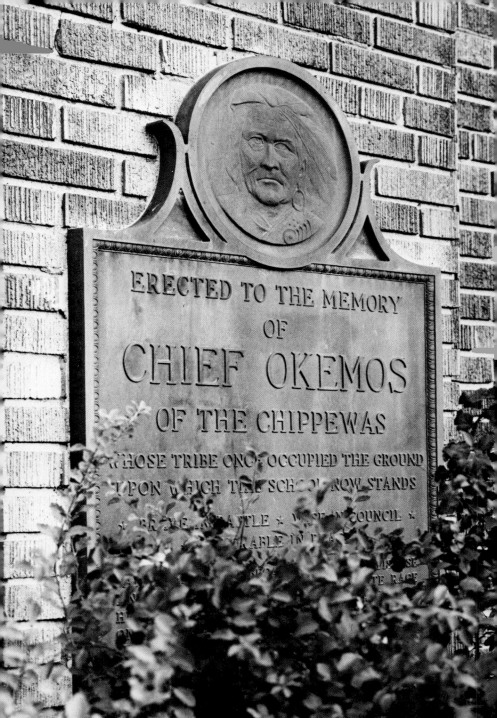

ERECTED TO THE MEMORY

OF

CHIEF OKEMOS

OF THE CHIPPEWAS

WHOSE TRIBE ONCE OCCUPIED THE GROUND

UPON WHICH THE SCHOOL NOW STANDS

✶ BRAVE IN BATTLE ✶ WISE IN COUNCIL ✶

Artist Unknown

CHIEF OKEMOS MEMORIAL TABLET

1923, bronze, 4'8"

Central School (Consolidated Agricultural School, Meridian #2)
4406 Okemos Road, Okemos

This memorial to Chief Okemos (d. 1858), whose tribal
camping grounds later became the site of this school, was
erected under the auspices of the Ingham County Pioneer
Historical Society. Funds were collected from more than
2,000 school children in Ingham, Eaton, Clinton, Ionia,
and Shiawassee counties; additional money was provided
by the Ingham County Board of Supervisors and local
citizens. On October 19, 1923, the plaque on this new
school was dedicated amidst speeches, musical selections,
and a school pageant with scenes from Longfellow's
Hiawatha. It would appear that this likeness was taken
from a portrait of Chief Okemos which was painted by an
unknown artist and is now located in the Michigan
Historical Museum, Lansing, Michigan.

ARTISTS' BIOGRAPHIES

JACK BERGERON (1950-)
Born in Bay City and raised in Midland, Michigan, Bergeron
received a B.F.A. from Michigan State University in 1972 and an
M.A. from Central Michigan University in 1976. Among
Bergeron's works are *Mimi,* Central Michigan University, 1976,
and *Longform,* Impression 5 Museum, Lansing, Michigan, 1976. In
Lansing, Bergeron served as assistant sculptor for the *Windlord,*
Riverfront Park, 1978, and completed *Tut-Tut* for the Lansing
Civic Center and *Ascent* for Kingsley Community Center in 1979.
He has taught at Lansing Community College in Lansing,
Michigan, since 1977.

AHARON BEZALEL (1926-)
Born in Afghanistan, Bezalel immigrated to Jerusalem with his
family in 1937. In the early 1950s, he studied sculpture at the
Bezalel School of Art and began teaching at the Hadassah Alice
Seligsburg Vocational High School in Jerusalem. Since 1962,
Bezalel has devoted himself exclusively to sculpture and has had
one-man exhibitions in Boston, Chicago, Toronto, Paris,
Jerusalem, Tel Aviv and other cities. His large-scale outdoor works
in East Lansing include the untitled work at Congregation
Shaarey Zedek, 1968-1969 and *Man and His City,* 241 Building,
1970.

FRANK D. BLACK (1863-1927)
Born in South Bend, Indiana, Frank Black entered his father's
monument firm, A. Black & Son, at Hastings, Michigan, in 1888.
After Asbury's death in 1898, Frank moved the firm to Grand
Rapids. The firm, which never copied monuments on the grounds
that it would be immoral, is still in existence, though it passed out
of the family after Frank's death. Black organized the National
Retail Monument Dealer's Association in 1902 and was active in
state and national monument dealer associations and in the
placement of several monuments in Michigan.

SAMUEL A. CASHWAN (1900-)

Born in Cherkassi, Kiev, Russia, Cashwan studied at the John Wicker School, City College of Detroit; the Architectural League, New York; and at the École des Beaux-Arts with Émile Antoine Bourdelle (1861-1929) from 1923 to 1926. He taught at and was head of the Sculpture Department at the Detroit Society of Arts and Crafts from 1926 to 1942 and he was a designer for General Motors Corporation from 1942 to 1965. Cashwan was also state supervisor for sculpture, ceramics, and allied arts for the Works Progress Administration, Federal Art Project, from 1936 to 1942. Cashwan's numerous Detroit area works include reliefs for St. Aloysius, 1936; Edwin Denby Memorial, 1939; *The Whale,* Southland Shopping Mall, 1968; *The Philosophers,* Congregation Shaarey Zedek, 1970; and an untitled work, Manufacturer's Bank, 1971. His Lansing works include *Aquarius,* Water Conditioning Plant, 1938-1939 and *Open Cage,* Oldsmobile Division, 1966. His works located on the Michigan State University Campus include the Abbott Street Entrance Marker, 1938-1939; "Three Musicians," c. 1940; Music Building and Olin Memorial Hospital reliefs, 1939; and *Prometheus,* Union Building, 1948.

CHARLES O. COOPER (1911-)

Born in New York and raised in Barre, Vermont, Cooper followed his father and two brothers into the monument industry. He received a B.A. in art from the University of Vermont and studied sculpture with Donato Colletti at the Barre Art School. Cooper was employed in the Lansing area at the Marsh Monument Company and Yunker Memorials, Inc. He later set up his own studio and firm, Williamston Memorials. Among his works in the Lansing area are the statue of Christ, Faith Lutheran Church, Okemos, 1961 and the *Ascension Shrine,* St. Joseph Catholic Cemetery, 1969.

LEONARD CRUNELLE (1872-1944)

Born in Lens, France, Crunelle immigrated to the United States as a young boy. He studied at the Chicago Art Institute and was a student and associate of Lorado Taft (1860-1936), well-known sculptor, lecturer, and author. Particularly known for his sculpture of children, Crunelle's many other works include *Governor Richard Oglesby*, the *George Washington-Robert Morris-Haym Solomon Memorial*, and the *Negro War Memorial*, all in Chicago; Lincoln statues in Dixon and Freeport, Illinois; a memorial to Dr. William M. Mayo, Rochester, Minnesota; and *General Artemas Ward*, Washington, D.C. He also modeled the *Dr. George E. Ranney Relief*, Mt. Hope Cemetery, Lansing, Michigan, c. 1914.

JOSÉ DE RIVERA (1904-)

Born in Baton Rouge, Louisiana, José A. Ruiz later adopted his maternal grandmother's maiden name de Rivera. His family moved to New Orleans when he was a young boy and he learned machine skills from his father who was an engineer in a sugar mill. He graduated from high school in 1922 and two years later went to Chicago where he found employment in foundries and machine shops. He also studied drawing at the Studio School with John W. Norton (1876-1934) from 1928 to 1931. After a year of travel and independent study in Europe and North Africa in 1932, de Rivera decided to become a professional sculptor, and he helped to pioneer the modern sculpture movement in America. Among de Rivera's many works are *Flight*, Newark Museum, 1938, originally created through the Works Progress Administration for the Newark airport; two World's Fair pieces, *Brussels Construction*, 1958, and *Construction for the New York World's Fair*, 1964; *Infinity*, National Museum of History and Technology, Smithsonian Institution, 1966; *Construction #150*, Washington Square Mall, Lansing, Michigan, 1972.

MARTIN EICHINGER (1949-)

Eichinger was born in Bay City and raised in Midland, Michigan. After six months of travel and independent study in Europe in 1970, he received a B.S. from Ferris State College in 1971. He was employed as a designer at Delta College, Bay City, until he opened his own studio in Lansing in 1974. He was consulting designer for the Ascension Lutheran Chapel, Lansing, Michigan in 1978. His Lansing works include the *Windlord*, Riverfront Park, 1978; *Ukor*, the Bulkanian Dragon, Impression 5 Museum, 1978, created with the help of the Popular Arts Workshop; and *Aqueous*, Michigan School for the Blind, scheduled to be completed in 1980.

ROBERT ELLISON (1946-)

Born in Detroit, Michigan, Ellison received a B.F.A. in 1969 and an M.F.A. in 1971 from Michigan State University. After graduation he went to San Francisco and began teaching around 1974 at the College of Marin, Kentfield, California. Among Ellison's works are an untitled sculpture at Universal Steel, Lansing, Michigan, 1970, and *Four Times Daily*, Civic Center Plaza, San Francisco, California, 1978.

ROBERT FORGRAVE (1955-)

A Lansing native, Forgrave received a B.F.A. from Michigan State University in March of 1979. His untitled sculpture was created for the Professional Building, Lansing, Michigan, in 1978.

DORIS HALL (1907-)

Born in Cleveland, Ohio, Hall studied at the Cleveland Institute of Art and the Hawthorne School in Provincetown, Massachusetts. She was Art Director, with her husband Kalman Kubinyi (1906-1973), at the Bettinger Corporation, Waltham, Massachusetts, from 1953 to 1959. Both a designer and a painter, she and Kubinyi created three enamel sculptures, *Aquarius, Aries,* and *Pisces*, for the Brody Complex, Michigan State University, East Lansing,

Michigan, 1956. Among her other works are an enamel mural, Whiting Lane School, West Hartford, Connecticut, 1952; enamel candlesticks, Immanuel Lutheran Church, Chicago, 1955; and a ceiling mural, Sidney Hill Country Club, Chestnut Hill, Massachusetts, 1956.

H. JAMES HAY (1942-)

Born in Detroit, Hay received an Associate of Arts Degree in 1963 from Northwestern Michigan College and a B.F.A. in 1965 and an M.F.A. in 1968 from Michigan State University. He has taught at Olivet College, Olivet, Michigan, since 1968. Among Hay's works are *Tree of America*, American Legion Headquarters, Lansing, Michigan, 1976, and *Spiritual Sunrise*, United Church of Christ, Washington, D.C., 1977.

MICHAEL HEIZER (1944-)

Born in Berkeley, California, Heizer visited archaeological sites with his father as a boy. He studied painting at the San Francisco Art Insitute from 1963 to 1964 and turned to creating earthworks in 1966. Among his large environmental works are *Double Negative*, Virgin River Mesa, Nevada, 1969; *City/Complex One*, Hiko, Nevada; *Displaced/Replaced Mass*, Hiko Nevada, 1974; *Adjacent, Against, Upon*, Seattle, 1976; and *This Equals That*, Lansing, Michigan, scheduled to be completed in 1980.

WILLIAM J. HEUSTED (1948-)

Born in the Saginaw Bay area in Caro, Michigan, Heusted received a B.F.A. in 1975 and an M.F.A. in 1977 from Michigan State University. He has also taken courses at several other schools, including the Universities of New Hampshire, South Carolina, Madrid, and Arizona. Heusted, who is equally at home with clay, taught at the University of Arizona in 1978. In addition to works in private collections, his *Embrace* is located at the Michigan Education Association Building, East Lansing, Michigan, 1977.

JERALD W. JACKARD (JACQUARD) (1937-)
Born in Lansing, Michigan, Jackard studied sculpture at Michigan
State University where he received a B.A. in 1960 and M.A. in
1962. After graduation he taught at the Kalamazoo Institute of
Arts until 1966, with 1963 spent studying bronze casting in
Florence under a Fulbright Scholarship. From 1966 until 1975 he
taught at the University of Illinois, Chicago Circle Campus, and is
currently teaching at Indiana University. He received a
Guggenheim Fellowship in 1972. Jackard's works include an
untitled sculpture at Kresge Art Center Gallery, Michigan State
University, East Lansing, Michigan, 1965; *Silent Defender*, a
purchase prize of the Detroit Institute of Arts in 1965; the *Passing
of Colored Volume*, Kalamazoo Institute of Arts, Kalamazoo,
Michigan, 1968; and a commissioned work for the Chicago
Transit Authority, 1974.

DALE JOHNSON (1947-)
Born in Detroit, Johnson received a B.F.A. in 1969 and an M.F.A.
in 1975 from Michigan State University. He has taught at Lansing
Community College since 1976. Among his works are the untitled
piece at Impression 5 Museum, Lansing, Michigan, 1976, and
Transit, East Detroit High School, 1979.

LEONARD D. JUNGWIRTH (1903-1963)
Born in Detroit, the son of a woodcarver, Jungwirth graduated
with a degree in Architectural Engineering from the University of
Detroit in 1927. After graduation, he worked in his father's studio
until 1936, with the exception of the years 1929-1933, which were
spent at the Academy of Fine Art in Munich, Germany. From
1936 to 1940 he taught woodcarving at Wayne University (now
Wayne State University) and was supervisor for the Works
Progress Administration, Federal Art Project in Detroit. He
received an M.F.A. from Wayne University in 1940 and taught
sculpture at Michigan State University from 1940 to 1963. Besides
a medal for the Dominican Republic, his works in Michigan include

the *Gabriel Richards Monument,* Belle Isle, Detroit, 1937-1940; a
fountain for Sigma Gamma Hospital School, Mt. Clemens, c.
1940; *Spartan,* Michigan State University, East Lansing, c. 1944;
City Seal, Lansing City Hall, c. 1956-1958; and *Composition With
Two Reclining Figures,* Detroit Institute of Arts, c. 1956.

JOSEPH E. KINNEBREW IV (1942-)

Born in Tacoma, Washington, Kinnebrew received a B.A. from
Syracuse University in 1964 and an M.F.A. from Michigan State
University in 1970. Among Kinnebrew's works are an untitled
sculpture, Harris Bank & Trust, Chicago, 1967; *Diagrams,*
University of San Francisco, 1974; untitled work, Wayne State
Health Care Institute, Detroit, 1979; and the *William A. Brenke
River Sculpture/Fish Ladder,* Lansing, Michigan, scheduled to be
completed in 1980. His Grand Rapids, Michigan, works include
Stroll, Grand Rapids Junior College, c. 1973; *Grand River Sculpture
and Fish Ladder,* 1974; *Kid Katwalk,* Sixth Street Bridge Park, 1975;
and *Here Man's Desire...*("Justice"), Hall of Justice, 1978.

THEODORE ALICE RUGGLES KITSON (1871-1932)

Born in Brookline, Massachusetts, Kitson studied in Paris with
Dagan-Bouveret. She received honorable mention at both the
Paris Exposition in 1889 and the Paris Salon of 1890, the latter
award being the first ever given to an American woman. She also
studied with the American sculptor Henry Hudson Kitson (1865-
1947) whom she married in 1893. She executed many public
sculptures which are located throughout the United States,
including *Kosciusko,* Boston, Massachusetts; *Victory,* Hingham,
Massachusetts; the *Volunteer of '61,* Newburyport, Massachusetts,
1902; eight portrait medallions for the General Sherman
Monument, Washington, D.C., 1903; and *The Hiker,* Minneapolis,
Minnesota. Approximately fifty castings have been made of the
latter, including three in Michigan, in the cities of Grand Rapids, c.
1927, Kalamazoo, c. 1923, and Lansing, c. 1945. The last *Hiker* was
erected in Washington, D.C. in 1964.

KALMAN M. B. KUBINYI (1906-1973)
Born in Cleveland, Ohio, Kubinyi graduated from the Cleveland
Institute of Art in 1929. He also studied with Alexander Von
Kubinyi in Munich. He taught at the John Huntington Polytechnic
Institute from 1929 to 1941, at the Cleveland Museum of Art and
the Cleveland Institute of Art from 1929 to 1936, and at
Cranbrook Academy of Art, Bloomfield Hills, Michigan, from
1948 to 1950. While in Cleveland, he was supervisor for the
Federal Art Project from 1938 to 1940. He was Art Director, with
his wife Doris Hall (1907-), at the Bettinger Corporation,
Waltham, Massachusetts, from 1953 to 1959. He and Hall created
three enamel sculptures, *Aquarius, Aries,* and *Pisces,* for the Brody
Complex, Michigan State University, East Lansing, Michigan,
1956. Besides an enamelist, Kubinyi was also a printmaker,
painter, and illustrator.

SUBRATA LAHIRI (1932-)
Born in Calcutta, India, Lahiri received a degree from the
University of Calcutta and an M.F.A. from Michigan State
University in 1965. Lahiri was head of the Sculpture Department
at the University of Calcutta for four years and is currently
teaching at the University of Arkansas at Fayetteville. Besides his
works in India, his sculpture includes *Eleanor Roosevelt,*
Department of Education, Washington, D.C.; *Abraham Lincoln,*
Hall of Fame, New York University, University Heights, New
York City; a relief at the Manhattan Gears Building, New York;
Metamorphosis I, Tokyo University, Japan; *Metamorphosis II,*
Michigan State University, 1965; and *Metamorphosis III,* University
of Arkansas, Fayetteville, Arkansas.

LEE LAWRIE (1877-1963)
Born in Rixdorf, Germany, Lawrie immigrated to the United
States as a small child. He entered the Chicago studio of Richard
Henry Park (1871-?) at the age of fourteen and later worked
with sculptors like A. Phimister Proctor (1862-1950), Philip
Martiny (1858-1927), and Augustus Saint-Gaudens (1848-1907).
He taught at Yale University from 1908 to 1919, receiving a

B.F.A. from that university in 1910 and an honorary M.A. in 1932. He also taught at Harvard University from 1910 to 1912. Known as the "Dean of American architectural sculpture," he collaborated on many buildings with the architect Bertram C. Goodhue (1869-1924), including the Nebraska State Capitol which is surmounted by a figure of *The Sower*. A similar relief figure can be found on a medal for the Society of Medalists and the facade of Beaumont Tower, Michigan State University, East Lansing, Michigan, c. 1929. Some of Lawrie's other works include the *Atlas*, Rockefeller Center, New York; and sculpture for the United States Military Academy, West Point; St. Thomas Church, New York, Harkness Memorial Quadrangle, Yale University; Library of Congress Annex Building, Washington, D.C.; the Fidelity Mutual Life Insurance Building, Philadelphia; and the Los Angeles Public Library.

MELVIN G. LEISEROWITZ (1925-)
Born in Des Moines, Leiserowitz received a B.A. in 1948 and an M.A. in 1964 from the State University of Iowa. Leiserowitz worked as an advertising executive, wholesale buyer, and importer, primarily in Des Moines, from 1948 to 1964. He began teaching at Michigan State University in 1964. His works include the untitled piece, State Center for the Performing Arts, Michigan State University, 1979, and several pieces in private collections.

DONALD H. MARCH (1926-)
March studied painting and ceramics at Colorado State University from 1948 to 1950 and received a B.F.A. and an M.F.A. from New York University's College of Ceramics located at Alfred University, Alfred, New York. He taught at Oklahoma University in 1957 and from 1958 to 1962 for the University of Michigan Extension Office in Grand Rapids. Since 1962 he has been employed by the United States Government in the Recreation Services Division Arts and Crafts Program. He taught at Fort Sheridan, Illinois, and since 1977 he has been Director of the Arts and Crafts Branch in the Panama Canal Zone. March's only public commission is *World Without End,* Davenport Building, Lansing, Michigan, 1961.

CLIVIA CALDER MORRISON (1909-)

Morrison studied with Samuel Cashwan (1900-) at the
Detroit Society of Arts and Crafts and began teaching there after
her graduation in 1932. She also studied with William Zorach
(1887-1966) at the Art Students League in New York and was
Ceramic Supervisor for the Works Progress Administration,
Federal Art Project, in Michigan. More than one thousand of her
works can be found throughout the United States, Canada, and
Europe. Her works in Lansing include *Children Reading*, Sarah
Langdon Williams Hall, Michigan State University, c. 1938; reliefs
over the fireplace, Louise H. Campbell Hall, Michigan State
University, c. 1941; and fountain, Water Conditioning Plant, c.
1941.

CORRADO JOSEPH PARDUCCI (1900-)

Born in Pisa, Italy, Parducci came to New York in 1904 and
graduated from P.S. 95 in 1915. He was introduced to
architectural modeling when he began working for Donnelly and
Ricci and served an apprenticeship with Ricci and Zari from 1917
to 1921. While in New York he studied at the Beaux-Arts
Institute of Design and with George Bridgman (1864-1943) at the
Art Students League. After the apprenticeship, he was employed
by Anthony di Lorenzo who sent him to Detroit in 1924. Parducci
stayed on and opened his own studio in 1925. His numerous
commissions can be found throughout the United States. Among
his Detroit works are the Bear Fountain at the Zoo, the Buhl,
Fisher, and Guardian buildings, Meadowbrook Hall, and the Music
Hall Theater. His Lansing works include the First Baptist Church,
Pilgrim Congregational Church, Grace Lutheran Church, St.
Paul's Episcopal Church, Lansing Bell Telephone Company, and
Sexton High School. His works can also be found on the
Kalamazoo County Building, Kalamazoo, Michigan, and the
Grand Rapids Civic Auditorium and the Michigan National Bank
Building (Grand Rapids Trust), Grand Rapids, Michigan.

EDITH BARRETTO STEVENS PARSONS (1878-1956)
Born in Houston, Virginia, Parsons studied at the Art Students
League in New York with Daniel Chester French (1850-1931) and
George Grey Barnard (1863-1938). Among her works are *Fish
Baby*, Evergreen Cemetery, Lansing, Michigan; *Frog Baby*,
Brookgreen Gardens, South Carolina; *Turtle Baby*, Cleveland
Museum; *Duck Girl*, Metropolitan Museum of Art, New York;
Soldiers Monument, Summit, New Jersey; and John Galloway
Memorial, Memphis, Tennessee.

EDWARD CLARK POTTER (1857-1923)
Potter was born in New London, Connecticut, and graduated
from Amherst College in 1882. He studied at the Boston School of
Fine Arts that same year and with Daniel Chester French (1850-
1931) from 1883 to 1884. The following two years Potter
supervised the cutting of French's Boston Custom House figures
at the Proctor marble quarry in Vermont and then studied in Paris
with Marius Jean Antonon Mercié (1845-1916) and Emmanuel
Frémiet (1824-1910). Potter modeled the horses for several
equestrian collaborations with French including the Columbus
Quadriga for the World's Columbian Exposition, Chicago, 1893;
General Grant, Philadelphia, 1897; and *General Hooker*, Boston,
1903. Among Potter's individual commissions are *Robert Fulton*,
Library of Congress, c. 1899; the lions at the New York Public
Libarary, c. 1900; *General Slocum*, Gettysburg, 1902; and *General
Philip Kearney*, Arlington National Cemetery, 1914. Works found
in Michigan are *Austin Blair*, Lansing, 1897, and *General George A.
Custer*, Monroe, 1909.

ULYSSES ANTHONY RICCI (1888-1960)
Born in New York, Ricci was an apprentice at the Perth Amboy
Terra Cotta Works in New Jersey from 1902 to 1906. He studied
at Cooper Union Institute from 1909 to 1910 and at the Art
Students League with James Earle Fraser (1876-1953) and George
Bridgman (1864-1943) from 1910 to 1912. He opened his own
studio in 1914 and was a partner in the firm of Ricci and Zari
from 1917 to 1941. Ricci's numerous works include the seal and
medals for the city of Detroit; *Father Le Moyne,* Le Moyne College,
Syracuse, New York; the Bowery Savings Bank, New York, 1922;
the American Institute of Pharmacy Building, Washington, D.C.,
1934; the Department of Commerce Building, Washington, D.C.,
c. 1930-1932; the doors of the Iranian Embassy, Washington,
D.C., 1960; and the Bank of Lansing (City National Bank),
Lansing, Michigan, 1931-1932.

WOODY (EDWIN W.) SANFORD (1912-)
A native of Lansing, Michigan, Sanford studied art with Alma
Goetsch and Kathrine Winckler at Michigan State University and
then at the Chicago Art Institute from 1935 to 36. The following
two years Sanford was employed as a gallery director in Chicago
through the Works Progress Administration (WPA). Since that
time Sanford has been a designer in Chicago and Lansing. He
recently retired after 27 years with Oldsmobile Division, General
Motors Corporation, Lansing. His untitled work of 1974 is located
there.

CARL L. SCHMITZ (1900-1967)
Born in Metz, France, Schmitz served as an apprentice with a
cathedral sculptor from 1914 to 1916. He studied in Munich with
Joseph Wackerle (1880-1959) at the State School of Applied Art
and with Albert Hahn at the State Academy of Fine Arts and in New
York at the Beaux Arts Institute of Design. Later he taught there
as well as at the Art Workshop and the National Academy of
Design. He received a Guggenheim Fellowship in 1944. While

teaching at Michigan State College (now Michigan State University) in 1947, he executed the reliefs for the Physics and Mathematics Building. Other works include the Delaware Tercentenary Half-Dollar; *Grover Cleveland,* New York City College; *Pietà,* Sorrowful Mother Shrine, Chicago; and, in Washington, D.C., the Justice Department Building, 1934, the Post Office Department Building, 1934, the Federal Trade Commission Buiding, 1937, and the *Lion and the Sun,* Iranian Embassy, 1960.

KRISTIAN E. SCHNEIDER (1863-1935)

Born in Norway, Schneider came to the United States when he was twenty years old. He studied with Louis Sullivan (1856-1924) and prepared the models for many of his buildings. Schneider was chief sculptor for the American Terra Cotta Corporation in Chicago from 1906 to 1930 and was then employed for the next five years at the Midland Terra Cotta Corporation. It was while he was at the fomer corporation that he executed the terra cotta reliefs for the Michigan Theatre (Strand Theatre and Arcade), Lansing, Michigan, 1921. His other works include the Golden Arch, Transportation Building, World's Columbian Exposition, 1893; Auditorium Building, Chicago, 1889; Wainwright Building, St. Louis, 1890-91; Prudential Building, Buffalo, 1894-95; Carson Pirie Scott Company, Chicago, 1899; Woodbury County Courthouse, Sioux City; and Louis Sullivan's tomb, Chicago, c. 1930.

JOHN T. SCOTT (1940-)

Born in New Orleans, Scott received a B.A. from Xavier University in 1962 and an M.F.A. from Michigan State University in 1965. He has taught at Xavier since 1965 and became chairperson of the Department of Art in 1976. In addition to his *Pietà,* East Lansing, Michigan, c. 1965, his work can be found at St. Angela Marici Church, Metaire, Louisiana, 1968, and Mount Carmel High School, New Orleans, 1969.

TIM TAYLOR (1950-)

A native of Lansing, Taylor created *George* in 1976 while an employee at Titus The Tinner, Lansing, Michigan.

PETER TOTH (1947-)

Born in Hungary, Toth came to Akron, Ohio, with this family at the age of 11. He is a self-taught carver who watched his father carve toys for his brothers and sisters. He worked in a machine shop and attended Akron University until he decided, in 1971, to erect a monument to the American Indian in each of the fifty states. His fifteenth monument was erected in Lansing, Michigan, in 1975. Toward the end of 1978, his 29th monument was placed in Troy, Kansas.

FRANK C. VARGA (1943-)

Born in Budapest, Hungary, Varga apprenticed with his father, Ferenc (1906-), from 1956 to 1961. He studied at the Academy of Fine Arts in Florence, Italy, from 1962 to 1964. His works in Lansing include *Saint Francis,* c. 1962, and the *Virgin Mary,* Immaculate Heart of Mary, 1965. Other sculptures include *Nicolas Copernicus,* Detroit Public Library; *Chief Pontiac,* Pontiac; *Martin Luther,* Jackson; *Pietà,* Flint; and the *Hurricane,* Belle Glade, Florida.

CARL HERMAN WEHNER (1848-1921)

Born in Prussia, Wehner's family immigrated to Sebewaing, near Bay City, Michigan, when he was a young child. His artistic abilities were recognized by Mrs. S. M. Fraser who sent him to study with Henry Kirke Brown (1814-1886) at Newburgh, New York. Wehner was also associated with John Quincy Adams Ward (1830-1910). He came to Lansing to model *The Rise and Progress of Michigan* for the Capitol pediment around 1875 and maintained a studio in the city for a few years. His other Lansing works include *Orlando M. Barnes; The Michigan Pioneer,* 1877; and *Henry Pattengill,* 1883. He settled in Detroit and some of his later works include the *Reverend S. S. Marquis; Murillo Castelar Palmer,* c. 1892; *Governor John J. Bagley; General John Pulford;* and *Francis A. Blades,* c. 1914.

ROBERT L. WEIL (1932-)

Born in Alexandria, Louisiana, Weil came to Detroit in 1944. He
received a B.S. in 1958 and an M.A. in 1963 from Wayne State
University and taught in the Detroit Public Schools from 1958 to
1961. Since 1962 he has taught at Michigan State University. His
Lansing area works include a playground sculpture for Edgewood
Village Children's Center, 1974, and the *Salt Shed,* 1975-76.

MELISSA WILLIAMS [MARTIN] (1940-)

Born in Binghamton, New York, Williams attended Hillsdale
College and graduated from Michigan State University with a
B.A. in 1970 and an M.A. in 1974. She has taught in the East
Lansing School System since 1970 and her *Ascension* of 1976 is
located at the East Lansing High School, East Lansing, Michigan.

JAMES WOLFE (1944-)

Born in New York, Wolfe is a graduate of Solebury School.
Considered to be of the Anthony Caro school, he taught at
Bennington College, Vermont from 1967 to 1969. Wolfe's works
include *Madness of the Goldfish,* 1974, East Lansing, Michigan; *Slope,*
Houston, Texas; and *Shilock,* Boston, Massachusetts.

THOMAS E. YOUNG (1941-)

Born in Hackensack, New Jersey, Young received a B.S. from
Michigan State University in 1961, a B.F.A. in 1969, and an
M.F.A. in 1971. He began teaching at that university in 1971. His
Lansing works include the untitled sculpture in the East Lansing
Allé, 1976; *Zonker I,* Long's Restaurant, 1974; and an untitled
relief at Builder's Redi-Mix, 1973. His 1978 sculpture, *Silhouette of
a Memory,* is located at the Junior High School in Addison,
Michigan.

W. ROBERT YOUNGMAN (1927-)

Born in Murphysboro, Illinois, Youngman learned blacksmithing and woodworking from his father and grandfather. He received a B.F.A. from the University of Illinois in 1950 and an M.F.A. from Southern Illinois University in 1953. He has taught in the Marion Public Schools, Marion, Illinois, from 1952 to 1953; at the University of Illinois, Champaign-Urbana, 1954 to 1959; at Anderson College, Anderson, Indiana, from 1959 to 1967, where he was also chairperson of the Department of Art; and at the University of Illinois, Champaign-Urbana, from 1969 to the present. In Michigan his works include the fountain and wall reliefs for North Washington Square Mall, Lansing, 1972-1973; and reliefs in the Detroit area for the Manufacturers National Bank Building, 1970, Webber Memorial Building, Harper-Grace Hospital, 1973, and the Michael Berry International Terminal, Detroit Metropolitan Wayne County Airport, 1974.

SELECT BIBLIOGRAPHY

Andrus, Percy H. "Historical Markers and Memorials in Michigan."
Michigan History Magazine 15 (Spring 1931): 167-374.

Armstrong, Tom, et al. *200 Years of American Sculpture.* [Boston]:
David R. Godine in association with the Whitney Museum,
1976.

Burroughs, Clyde H. "Painting and Sculpture in Michigan."
Michigan History Magazine 20 (Autumn 1936): 395-409 and 21
(Spring 1937): 39-54, 141-157.

Craven, Wayne. *Sculpture in America.* New York: Crowell, 1968.

Doezma, Marianne and Hargrove, June. *The Public Monument and
Its Audience.* Cleveland: The Cleveland Museum of Art, 1977.

Durant, Samuel W. *History of Ingham and Eaton Counties, Michigan.*
Philadelphia: D. W. Ensign & Co., 1880.

Ekdahl, Janis. *American Sculpture.* Art and Architecture Information
Guide Series, vol. 5. Detroit: Gale Research Co., 1977.

Friedlander, Lee. *The American Monument.* New York: The Eakins
Press Foundation, 1976.

Gibson, Arthur Hopkin (comp.). *Artists of Early Michigan.* Detroit:
Wayne State University Press, 1975.

Goode, James M. *The Outdoor Sculpture of Washington, D.C.*
Washington, D.C.: Smithsonian Institution Press, 1974.

Janeti, Joe (ed.). *From the Bottom Up: 15 Contemporary Michigan Sculptors.*
Section introductions by Bob Weil. [East Lansing, Michigan,
1977 (?)].

May, George S. (comp.). *Michigan Civil War Monuments.* Lansing:
Civil War Centennial Observance Commission, 1965.

Proske, Beatrice Gilman. *Brookgreen Gardens Sculpture.* New ed., rev.
and enl. Brookgreen, South Carolina: Brookgreen Gardens, 1968.

Robinette, Margaret A. *Outdoor Sculpture, Object and Environment.*
New York: Watson-Guptill Publications, 1976.

Sculpture of a City: Philadelphia's Treasures in Bronze and Stone.
New York: Walker Publishing Co., Inc., 1974.

Taft, Lorado. *The History of American Sculpture.* New edition with a
supplementary chapter by Adeline Adams. New York:
The Macmillan Co., 1930.

NOTE

 While the above have been helpful, much of the documentary
material was collected in bits and pieces from a variety of sources
including local and state libraries, archives, museums, interviews, and
a field inventory. Source materials include an inventory form with
bibliography and photograph for each sculpture; local, county, and
state histories; newspaper and magazine articles; correspondence;
photographs; and dedication booklets. All of the documentation will
be housed in the Michigan State University Archives and Historical
Collections, East Lansing, Michigan.

INDEX

Abbott Road Entrance Marker (Cashwan), 108, 109

Administration Building, Oldsmobile Division, General Motors Corporation, 44

American Legion Headquarters, 71

Aquarius (Cashwan), 6, 48, 49

Aquarius (Hall and Kubinyi), 104, 105

Aries, (Hall and Kubinyi), 104, 105

Ascension (Williams), 2, 7, 118, 119

Ascension Shrine (Cooper), 64, 65

Band Shell, Michigan State University, 110

Bank of Lansing Reliefs (Ricci), 2, 8, 30, 31, 32, 33, back cover

Beaumont, John W., 113

Beaumont Tower, 2, 113

Bergeron, Jack, 7, 78, 79, 133

Bezalel, Aharon, 122, 123, 124, 125, 133

Black, Frank D., 4, 20, 21, 133

Black, Kenneth C., Lansing, 25, 30, 48

Black, Lee, Lansing, 25, 30, 48

Blair, Austin (Potter), 4, 8, 14, 15

Blair, Governor Austin, 3, 15

"*Boy Reading a Book*" (Artist Unknown), 42, 43

Brenke, Councilman William A., 57

Brenke, William A. River Sculpture/Fish Ladder (Kinnebrew), 9, 56, 57

Brody Dorm Complex, Michigan State University, 104

Bronkema, James R., 35

Burchard, Colonel John W., 57

Burchard Park, East, 57

Butler, John W., 1

Butterfield, Colonel Walter Scott, 26

Butterfield Hall, Michigan State University, 104

Calder, Ralph, Detroit, 104, 107, 114

Capitol Building, 1, 2, 8, 16, 17, 25, 30

Capitol lawn, 3, 4, 15, 21

Cashwan, Samuel, 6, 44, 45, 48, 49, 108, 109, 110, 111, 114, 115, 134

Caudill, Rowlett, and Scott, Houston, 93

Central School, Okemos, 131

Chief Okemos Memorial Tablet (Artist Unknown), 2, 130, 131

Children Reading (Morrison), 6, 106, 107

Churchill, Judson, Newell, Lansing, 43

City Hall, 2, 25

City National Bank. *See* Bank of Lansing Reliefs

City seal, 2, 25

City Seal (Jungwirth), 5, 24, 25

Congregation Shaarey Zedek, 124

Construction #150 (de Rivera), 7, 8, 28, 29, 53

Cooper, Charles O., 64, 65, 134

Crunelle, Leonard, 5, 84, 85, 135

Cyclotron Laboratory, Michigan State University, 95

De Rivera, José, 7, 8, 28, 29, 53, 135

Donaldson, John M., Detroit, 113

East Lansing Fine Arts and Cultural Heritage Committee, 79, 117

East Lansing High School, 119

Eberson, John, Chicago and New York, 26

Edgewood United Church, 127, 129

Edgewood Village Children's Center, 127

Education Building (West Junior High School), 42, 43

Eichinger, Martin, 7, 52, 53, 136

Ellison, Robert, front cover, 62, 63, 136

Embrace (Heusted), 120, 121

Emmons Hall, Michigan State University, 104

Evergreen Cemetery, 88

First Baptist Church, 40, 41

First Michigan Sharpshooters (Black), 4, 20, 21

First Regiment Michigan Engineers Monument (Artist Unknown), 4

Fischbach, Reverend Julius, 41

Fish Baby (Parsons), xi, 5, 88, 89

Forgrave, Robert James, 66, 67, 136

From the Bottom Up: Fifteen Contemporary Michigan Sculptors, 7, 79, 117

Gannett Foundation, 53
General Services Administration, Art-in-Architecture Program, 7
George (Taylor), 58, 59
Ginsburg, Alan, 122
Grand Ledge Clay Products Company, 103
Grant, General Ulysses S., 21
Greenly, Governor William L., 8
Gwahir, 53
Hall, Doris, 104, 105, 136, 137
Hannah, John A., 103
Hay, H. James, 4, 7, 70, 71, 137
Heizer, Michael, 9, 23, 137
Heusted, William J., 120, 121
Hiker, The (Kitson), 4, 18, 19
Holy Cross Friary, 68
Hopkins, E. L., 4
Impression 5 Museum, 79, 80
Indian Monument (Toth), 2, 76, 77
Ives, Lewis T., 17
Jackard, Jerald W., 98, 99, 138
Johnson, Dale, 80, 81, 138
Johnson, Johnson and Roy, 35
Jungwirth, Leonard, 2, 8, 24, 25, 60, 61, 102, 103, 138, 139
Kennedy, Mrs. John F., 129
Kinnebrew, Joseph E. IV, 9, 56, 57, 139
Kitson, Theodore Alice Ruggles, 4, 18, 19, 139
Kresge Art Gallery, Michigan State University, 98
Kubinyi, Kalman M. B., 104, 105, 140
Ladies' Monument Association of Lansing, 4
Lahiri, Subrata, 94, 95, 140
Lawrie, Lee, 2, 5, 8, 112, 113, 140, 141
Leiserowitz, Melvin, 9, 92, 93, 141
Little Arlington (Pizzano), 4
Longform (Bergeron), 7, 78, 79
Longstreet, Caroline, 82
Longstreet, Clarence, 82
Longstreet Monument, 3, 82, 83
Longstreet, William, 82
Lower Town, 1
Madness of the Goldfish (Wolfe), 96, 97
Man and His City (Bezalel), 122, 123
Manson, Elmer, Lansing, 41, 61

March, Donald H., 6, 36, 37, 141
Metamorphosis II (Lahiri), 94, 95
Metropolitan Lansing Fine Arts Council, 7, 29
Michigan Agricultural College. *See* Michigan State University
Michigan Bell Telephone Reliefs (Parducci), 6, 38, 39
Michigan Council for the Arts, 7
Michigan Education Association, 121
Michigan State College. *See* Michigan State University
Michigan State University, 1, 2, 6, 8, 9, 25, 30, 63, 93, 95, 96, 98, 101, 103, 104, 107, 108, 110, 113, 114
Michigan Theatre Reliefs (Schneider), 5, 26, 27
Michigan, town of, 1
Middle Town, 1
Morgan's Jewelers, 3
Morrison, Clivia Calder, 6, 106, 107, 142
Mt. Hope Cemetery, 3, 82, 84, 87
Munson, O. J., Lansing, 110
Music Building, Michigan State University, 110
Myers, Elijah E., Detroit, 17
National Endowment for the Arts, 7, 29
Natural Resources, Michigan Department of, 57
Oasis Fellowship, Incorporated, 46
Obelisk, 4
O'Boyle, Cowell, Rohrer & Associates, 55, 57
Oldenburg, Claes, 7, 29
Olds, Ransom Eli, 8, 41
Oldsmobile Division, General Motors Corporation, 8, 44
Olivet College, 71
Open Cage (Cashwan), 8, 44, 45
"*Owl in a Tree Trunk,*" Longstreet Monument (Artist Unknown), 3, 82, 83
Parducci, Corrado Joseph, 6, 38, 39, 40, 41, 72, 73, 142
Parsons, Edith Barretto Stevens, 5, 88, 89, 143
Patton, Honorable John, 3
Physics and Astronomy Building Reliefs (Schmitz), 8, 100, 101
Pietà (Scott), 128, 129
Pisces (Hall and Kubinyi), 104, 105
Pizzano, Charles A., 4

Potter, Edward Clark, 3, 8, 14, 15, 143
Potter Park, 76
Professional Building, 67
Prometheus (Cashwan), 114, 115
Public Works Administration (PWA), 73
Ranney, Dr. George E. Relief (Crunelle), 5, 84, 85
Reo Flying Cloud, 8, 30
Reutter Park (Central Park), 3
Ricci, Ulysses Anthony, 2, 8, 30, 31, 32, 33, 144, back cover
Rise and Progress of Michigan, The (Wehner), 2, 16, 17
Riverfront Park, 7, 53, 55
Rix, Charlotte B., 87
Rix Monument, 3, 86, 87
Saint Francis (Varga), 68, 69
Saint Joseph Cemetery, 64
Salt Shed (Weil), 7, 54, 55
Sanford, Woody (Edwin W.), 8, 46, 47, 144
Schmitz, Carl L., 8, 100, 101, 144, 145
Schneider, Kristian E., 5, 26, 27, 145
Scott, John T., 128, 129
Seth Thomas Clock, 3
Sexton, Dr. J. W., 73
Sexton, J. W. High School Reliefs (Parducci), 72, 73
Seymour, James, 1
Smith, Hinchman & Grylls, Detroit, 39
Soria, Martin S., 129
Sower, The (Lawrie), 2, 5, 8, 112, 113
Spartan (Jungwirth), 8, 102, 103
"Sparty." *See Spartan* (Jungwirth)
State Center for the Performing Arts, Michigan State University, 9, 93
Stewart, J. L., 4
Stieber, Joan, 53
Story, Inc., 46
Suffer the Little Children (Parducci), 40, 41
Taylor, Tim, 58, 59, 146
Three Bears (Jungwirth), 60, 61
"*Three Musicians*" (Cashwan), 110, 111
This Equals That (Heizer), 9, 22, 23
Titus the Tinner, 58
Tolkein Trilogy, 53
Toth, Peter, 2, 76, 77, 146

Tree of America (Hay), 4, 7, 70, 71
241 Building (Alco Building), 122
Union Building, Michigan State University, 114
Universal Steel Company, 63
Upper Town, 1
Urban Redevelopment Board, Lansing, 29
Urban renewal, 6, 7, 35, 55
Varga, Frank C., 68, 69, 146
WPA. *See* Work Projects Administration and Works Progress Administration
Warren Holmes Company, Lansing, 73
Washington Monument, 4
Washington Square Mall, 7, 26, 27, 28, 29, 30, 31, 32, 33, 34, 35
Water Conditioning Plant, 48, 49
Wehner, Carl Herman, 2, 16, 17, 146
Weil, Robert L., 7, 54, 55, 126, 127, 147
West Junior High School. *See* Education Building
Wharton, Clifton R. Jr., 93
Williams (Martin), Melissa, 2, 7, 118, 119
Williams, Sarah Langdon Hall, Michigan State University, 107
Willow Street School, 61
Windlord (Eichinger), 7, 52, 53
Windlord Media Project, 53
Wolfe, James, 96, 97, 147
"*Woman Clinging to a Cross,*" Rix Monument (Artist Unknown), 3, 86, 87
Work Projects Administration (WPA), 6
Works Progress Administration (WPA), Federal Art Project, 6, 48, 107, 108, 110
World Without End (March), 6, 36, 37
Yogerst, Frank, 8
Young, Thomas E., 7, 116, 117, 147
Youngman, W. Robert, 7, 34, 35, 148